W9-BBH-149

LUKAS & STERNBERG, NEW YORK 018

ANTON VIDOKLE
PRODUCE, DISTRIBUTE, DISCUSS, REPEAT

LUKAS *&* STERNBERG, NEW YORK

Anton Vidokle

Produce, Distribute, Discuss, Repeat

Publisher: Lukas & Sternberg, New York

Editor: Brian Sholis

Proofreading: Amy Patton

Design: Miriam Rech, Markus Weisbeck, Surface, Berlin/Frankfurt am Main

Printing and binding: Brandenburgische Universitätsdruckerei Potsdam

ISBN 978-1-933128-82-5

Lukas & Sternberg is an imprint of Sternberg Press.

Sternberg Press

Caroline Schneider

Karl-Marx-Allee 78, D-10243 Berlin

1182 Broadway #1602, New York, NY 10001

www.sternberg-press.com

CONTENTS

BRIAN SHOLIS
PREFACE

Anton Vidokle is an artist who commands the attention of 70,000 people each day. Yet comparatively few members of this audience consider him an artist, despite the fact that he has publicly identified himself as such for over a decade and has exhibited in museums and galleries across the world. The contributors to this book emphasize two aspects of his artistic practice that are partly responsible this disparity. The first characteristic is the self-effacing nature of his endeavors. Not only are many of his projects subsumed under an anonymous-sounding corporate identity, e-flux, but they are also nearly always collaborative. When one sees Vidokle's name as an author, it is almost invariably alongside that of his coauthors; his is one voice among many. The second quality is his relative freedom from the network of institutions that is generally believed to confer legitimacy upon individual artistic practices. While other well-known artists are financially independent and can more or less create what they want, this freedom is predicated on the ability of their artworks to cycle through such traditional venues as galleries and museums. In contrast, Vidokle, through e-flux, is able to produce, disseminate, and critically interrogate the ideas that animate his practice. He can also display the fruits of this process publicly and convene friends and collaborators to discuss and refine them. Vidokle doesn't shun conventional artistic institutions, but e-flux is a robustly healthy ecosystem that grants him the opportunity to engage them selectively.

The essays and interview that follow highlight how these two threads in Vidokle's practice—unobtrusiveness and the freedom of self-suffi-ciency—are often interwoven, and how they are at the center of an intellectual project that undermines commonplace assumptions about what it means to make art in the twenty-first century. What they don't stress further underscores how Vidokle is an unconventional artist. Despite the fact that this is the first book to survey Vidokle's artistic practice, it contains no illustrations; some would argue, perhaps Vidokle included, that there is nothing to illustrate. It also

encompasses only a very small swath of what he has actually created. There is little mention of, for example, the *e-flux video rental*, and other projects, such as *PAWNSHOP* and *An Image Bank for Everyday Revolutionary Life*, are entirely undiscussed. Julieta Aranda, Vidokle's partner in e-flux and an artist with her own thriving career, does not make much of an appearance in these pages.

The contributors instead focus on the theoretical implications of Vidokle's recent projects, many of which they participated in directly. In doing so, readers will come away with a clearer understanding of how the e-flux announcement service, which was founded by Vidokle with several collaborators in 1998 and which presents information to those thousands mentioned at the outset, relates to Vidokle's practice. The announcement service is a vehicle for content generated by others, as are many of the projects Vidokle creates. The announcement service, which takes the form of a thrice-daily e-mail, is radically decentralized, as are Vidokle's peripatetic endeavors, which can be found on several continents simultaneously. And the announcement service, an online-only endeavor, is incorporeal, as are the intellectual fruits of the conversations Vidokle convenes.

But by gathering together meditations upon and reminiscences of this radically dispersed output, this book momentarily focuses attention on the man behind it, and on the implications of his singular under-taking. Can one be an artist without making anything that is easily defined as art, even at a moment when nearly everything can be so designated? Can one play down one's own contributions to diverse projects and still be recognized as the point of convergence that unifies them? This book answers both questions with an emphatic yes.

JAN VERWOERT
GATHERING PEOPLE LIKE THOUGHTS

ON HOSTING AS AN UNORTHODOX FORM OF AUTHORSHIP DEDICATED TO THE PRACTICE OF
ANTON VIDOKLE

What is the relationship between hosting and authorship? Is a host an author? Is hosting a form of authorizing something? Authorizing what? A social process? With what authority? That of an author? Gathering people like one would gather thoughts? Perhaps. But if a host should be a little like an author, would an author then not also be a little like a host? Gathering thoughts like a host would summon guests? Maybe. If this, however, should be so, what does it mean for our understanding of hosting and authorship as forms of cultural production?

I won't be able to give you authoritative answers. This is because the position I speak from is tied up with the very questions I am trying to address: As an author, I speak to you now because I am being hosted by the artist Anton Vidokle—whose guest I am on these pages. He has been a good host to me many times, in the process of doing what he does as an artist and in this sense as an author, by creating places and occasions for creatures like me, him, you, us to gather, by attracting a public to engage with and by developing an economy to sustain our practice. Conversely, speaking from the position of a recurrent guest, being associated with my host, I find that in writing this text I, in my turn, should try host the spirit of this association. It's a matter of principle. As an author, I like to free associate and to associate myself freely with people who, like Vidokle, are dedicated to the spirit of free association, intellectually, socially, emotionally, spiritually, and politically. To mimic the form of this association through a mode of associating thoughts is what I would like to try here—to invoke, host, and voice the spirit of this exchange. This is just my voice. But if it is to have any resonance and credence, it should voice something else as well: the spirit in which free spirits would want to associate. If I can't voice it, I fail as an author because I fail these spirits as a host.

To begin with, here is a provisional definition of authorship: Authorship is founded through the creation of a voice. What is the job, the task, the vocation of this voice? Practically, it is to begin, to follow through and to conclude a discourse. A discourse? Meaning: a stream of words, thoughts, stories, ideas, or images, a series of articulations or manifestations unfolding (according to) a pattern, structure, or choreography that allows for ideas and emotions to take shape. To authorize then is to start a discourse by raising your voice and to begin speaking—assuming, perhaps presumptiously, that someone, anyone, would want to listen. To authorize also means to inhabit the space you open up through your voice, your discourse, to spend time in this space, furnish it and turn it into a place for living (which is what followthrough means: to learn and live with the profane reality of your works and words, once they are born, and stand by them). Finally, to authorize implies knowing a way to conclude, sum up and say what you said, to bring a point home and give an edge to it or, in a final unsuspected twist, throw everything open once more. These are the techniques of authorizing, the ones that matter. Technically, signing with your name also certainly plays a role. But, for a signature to signify, the symbolic act of signing alone won't do. It's only when the signature resonates with a voice, when a voice is resonating from within it, that the signature acquires any meaning, the little meaning it has by default, as one material trace produced in the course of the signifying practice of unfolding authorship. Call it a pragmatist idealist's convictions, call it experience, but I just think that this is how it works.

Now, what is the relationship between the voice of authorship and the authorship of hosting? At its most basic, the voice of authorship is only ever such a voice when it hosts other voices. (I should know. This is my second language. All words I use in English are gifts I have received or goods I have stolen from voices that have spoken to me.) The reason you listen to an author is because the associated words, ideas, stories, images, thought patterns, motifs, notions, and emotions

that constitute her or his voice actually resonate with other voices, including yours. Because the association of the integral elements of that voice testifies to a possible association of different spirits, bodies of thought and states of emotion. Because the space of the discourse opened up and furnished by the voice is inhabited (or haunted) by many spirits, bodies, and states and therefore presents itself, in an inviting way, as habitable, as a place to which you may want to come and spend time in the company of those spirits. Were that not so, a work would just speak to itself. Maybe not even that. A body of work that offers something for others to share is a resonating body that makes the voices of many others resound. Yet, for echoes and resonances to become audible someone, I believe, has to make a sound, play a tune, or lay down a rhythm. Someone has to start playing. One thing presupposes the other. For one voice to be a voice it takes many to give it its sound. And for many voices to resound, it seems, it takes a resonating body to make them audible.

If that should be so, though I may be jumping to conclusions here, then the subjectivity generated by hosting as a form of authorship and authorship as a form of hosting is by definition a collective sub-jectivity. Likewise collectivity—the mode in which people appear in the social world when they are drawn together or set apart by the force of particular desires and the urge to share them in specific ways—only comes into effect when it manifests itself in some kind of subjec-tivity that would make the multiplicity of its voices resonate. So, to speak of a subjectivity here, in this particular manner, is not an invocation of what is commonly, pejoratively, referred to as "subjectivism." There is no "ism", no ideology at play in the process by which a collec-tive subjectivity is instituted through being hosted by a voice. It is a simple material process, just a matter of practice and technique. The institution of a collective subjectivity is the material process through which a particular form of consciousness is generated in art and think-ing, a form of consciousness that is temporarily hosted by the work,

body, or space that generates it. Hosting in this sense is the act of lending a body, a mind, a soul to this consciousness for it to actualize itself under specific material conditions of space, time, and money. This particular consciousness couldn't exist otherwise. Being hosted by and within a collective subjectivity is the only mode of its possible existence. Ideology, of course, can always creep back into the process in which consciousness is produced in the mode of collective subjectivity. History shows that it often does. But it doesn't have to. The point is to find means to keep this from happening, by making things happen in a manner and spirit that is decidedly different.

Practically then, the authorship of the host is founded through a material practice as much as through the invocation of a particular spirit: a material practice that makes divergent forces converge as a collective subjectivity, even if only fleetingly, in the form of bodies, spaces, words, and works that resonate (with each other) in a spirit that defies ideology. One is inseparable from the other. Materially, collective subjectivities only emerge when the spirit is right, just as, conversely, the spirit only feels right when the material conditions in place allow the possibility of a collective subjectivity to emerge. But how does this work? Could there be a manual for teaching people the material practice and the spirit—the protocols and prayers—for authorizing this moment of emergence? Maybe, because if a certain pragmatism, a dedication to the practicalities of practice, were crucial to the authorship of the host, then writing a manual should be possible (if not imperative). Reflections on this form of authorship not addressing the profane reality of practice would miss the point. Likewise they would be useless if they didn't include advice on how to invoke the spirit of a collective subject and therefore, perhaps, read a little bit like a book of incantations.

Then, practically and spiritually, the magic of hosting would lie in mastering of the forms, formats and formalities that enable one to

summon people, spirits, ideas, and images. In other words, hosting would be the craft of conducting ceremonies of invocation and convocation according to a protocol that ensured not only that the gathering happens at all, but also that it happens in the desired spirit. This craft is a traditional skill. It belongs to the practical knowledge once passed on through traditions. In fact, you could say that this was one of the practical purposes of traditions: to provide proper occasions for gathering—in the form of religious holidays, for instance, or rites of passage such as baptisms, weddings, and funerals—and bestowing the office of the host on someone schooled in conducting those ceremonies. Likewise in art and thinking, traditions provided the reason and occasion to gather your thoughts and make work. These took the form of social events on the occasion of which a piece would be commissioned (e.g., a speech to be delivered, a play to be staged, a composition to be performed, new clothes to be worn, a painting to be revealed on or exhibited in commemoration of the event), but also in the form of motifs and genres that provide the reason—or rather, the pretext—for organizing your thoughts around a theme in the course of its interpretation.

The key to a defiant manner of handling these social customs tradition-ally resided in the art of taking the (re-)interpretation of an established convention, genre, or theme as the occasion to, on a subtextual level, let whatever other ideas one was entertaining slip into the commis-sioned piece. This clandestine practice of irreverent renditions is at the heart of the culture of unorthodoxy; it epitomizes the spirit of acting and thinking in defiance of ideology. Yet this is also precisely the manner in which good hosts—hosts who seek to invoke the spirit of criticality and convoke likeminded souls—would want to act and think. The question then is: How does one perform the practice of hosting in this different spirit, that is, in an unorthodox manner? How can one be an unorthodox host?

It's not easy. In fact, after the wholesale dismissal of tradition that characterized modernism we seem to find ourselves deprived of proper occasions for unorthodox action and thought. So, paradoxically, in the light of modernism's critique, to rely on the formalities of traditional protocol—if only to use them as a pretext for unorthodox interpretations—no longer feels like an option. Since, after the denigration of tradition, the proper occasion for a ceremony of gathering and the habitual authority of the master of that ceremony are no longer always already established in advance of their actual production, neither are the routines and authorities to unsettle so easily identified and targeted anymore. Consequently, the spirit of unorthodoxy wanders in search of houses to haunt. The challenge to the authorship of the contemporary host is therefore twofold. She or he must first of all invent a proper occasion for hosting and invent a pretext for gathering. As a contemporary host, the author—and, as a contemporary author, the host—is called forth to conjure up names of saints, seasons or rites of passage to celebrate and themes to interpret in order for guests to be invited, audiences to be invoked, thoughts to be gathered and works to be created. (This is what exhibition and event programming in art spaces or the commissioning of texts for a magazine—and likewise the development of themes to riff on in the process of writing or making art—is effectively about). The second and perhaps most demanding challenge is to host unorthodox spirits in an unorthodox manner, to give wandering spirits and hungry ghosts a home while potentially being one of them oneself. One must find a building for others to haunt while being in search of such a spiritual home oneself, thus, as a host, performing the double role of being the keeper of the building and one of the spirits that it houses.

But even if many old traditions have been dismissed, one might object, this does not mean they haven't been replaced by new orthodoxies. Don't those, then, also offer ample opportunities for clandestine engagement? Surely. The protocols of the art market, the

rites of academia or routines of museum culture, for instance, no doubt seem to present unorthodox spirits with many ceremonies in which to insinuate themselves and an overall social fabric into which to weave their own threads. Let's assume that this happens, and that to name those spirits would be to betray them. Yet, since it is the horizon of modernism within which we now seek to grasp the foundations of hosting as an unorthodox form of authorship (and authorship as an unorthodox form of hosting), the stakes are raised. This is because what modernism placed at stake is the dream and demand of autonomy: the hope and claim that the power of a cultural practice to truly make a difference was inseparable from the freedom to determine its own conditions. Despite the many disillusions that this hope will be exposed to in a lifetime and the general awareness of the intricate dependencies that entering the field of art inevitably produces, it would be plain mad to give up the claim to this freedom. Not least because, as contemporary host-authors, we do have a pride of profession to defend. And this professional ethos resides in the contentious assertion that we are free to summon—and be summoned by—the spirits we believe in and trust, and by those only.

It's laughable, I know, because after all we are talking about wandering spirits, and those are notoriously difficult to handle. To put your trust in them and ground an ethos in the possibility of their invocation seems extremely unwise. Can the hungry ghosts of unorthodox spirits ever be trusted to appear when summoned? Are they not way too volatile? Perhaps, but there must be ways to lure them. They are hungry. So it cannot possibly be that hard to offer them something to tempt their appetite, can it? But isn't this also precisely why hungry ghosts will never be faithful companions? Won't they accept any food offered and thus swallow anyone's bait? No, they won't. That we almost be sure of. Hungry ghosts cherish their hunger. They know that the promise of saturation is the appeal of bad faith. If there is autonomy, from the vantage point of hungry ghosts, it must lie in the ability to authorize

your hunger, to grasp its laws—the conditions of alienation, the ill logic of desires—and to get a grip on them so as to no longer be under the spell of these laws but rather in a position to twist them, in unorthodox ways, into unorthodox shapes. To do this sort of twisting in the pursuit of autonomy is precisely what defines the signifying practice of a modern host/author as unorthodox. It is in and through the performance of this twist that the authority of this kind of authorship is founded. It resides in this twist, in the joy, pain, anger and laughter emanating from this twist: in the spirit of your twisting.

Like the constitution of a subjectivity, the performance of the twist is a collective effort. No one can do this twist alone. To perform it, one must be aided by the supportive spirits of many a hungry ghost, twisted sister, or visitor arriving in your building, mind and work from nearby or far away to help you find the themes to improvise on as well as the occasions, pretexts, and techniques to do so. Like subjectivity, then, the authority of the twist is by definition shared and therefore divided, if not dissipated, between many spirits. It only comes into effect when the twist modifies the way in which those spirits think together, think of themselves together, or experience a different manner of being together in the very act of thinking together. The authority of the twist lies in its credence. This credence can only be generated and invested by an association of people who, together, validate a shared experience as credible. So the authority/credence (these thus being synonyms) of a twist is born out of the moment of sharing its experience. It's the momentum of this moment. It's the momentum of different spirits authorizing the experience they have produced together, through realizing that it has had an effect on—and in this sense acquires a certain authority/credence in relation to—the way they experience themselves and the mode in which they are together, differently, from now on.

If the twist is a shared moment with a certain momentum, it will very likely leave an imprint on your memories. But this imprint will remain unsigned. You cannot put a signature under the imprint of momentum. It is nothing anyone could claim as private property. The momentum of a twist is the public property of an assembly of unorthodox spirits, contingent on the manner of their association and the credence they might generate together. If collective subjectivity, then, is a form of consciousness (a spirit) produced through—inherent to and transported by—particular forms of material practice, then the practice of the twist is the mode by which the production of this material consciousness is modified. If performing the twist (in the act of interpreting a theme or an occasion in an irreverent fashion) is what unorthodox spirits desire to do, then the mode in which they would want to be hosted is one that invites such modifications. The nights and days Anton Vidokle has hosted in different places and buildings have left a an imprint on my memory that has modified my thinking. I'd like to believe that I have shared the momentum of this experience with others. But you shouldn't try to fix a twist in words like that. Sticking to formalities will only spoil it. Be that as it may, all of this is to say thank you. To the host!

MARIA LIND

DILEMMAS OF LOVE, HUMOR, AND CRITIQUE: NOTES ON THE WORK OF ANTON VIDOKLE

"Critique is an instrument," says Michel Foucault in reply to his own question in the 1978 lecture *What is critique?*[01] It is an instrument akin to virtue. Critique is a certain way of thinking and acting, a particular relationship to everything around us. It means doubting and challenging the politics of truth. Rather than locate the birth of modern critique in the high critical enterprise of Kant, Foucault traces the genealogy of the concept of critique back to medieval mysticism and the religious struggles and spiritual attitudes of the Reformation—to the "little polemical professional activities" of that period by which individuals established a hotline to celestial powers for doubts and concerns related to their emotions, conscience, and beliefs. Their queries did not halt at the spiritual but logically also brought them to the church's representatives on earth and the way in which people were governed. How to govern was, according to Foucault, a fundamental question during the fifteenth and sixteenth centuries. Many subjects came to the conclusion that they did not want to be governed "just like that" or "quite as much." They did not refuse outright to be governed but they wanted government to function otherwise.

The notions of not wanting to be governed "just like that" and how to "function otherwise" are embedded Anton Vidokle's artwork. Without getting too entangled with intentionality, it can be argued that these conceits are the underlying motivation for his artistic enterprise: How can we think things differently, from the points of view of formats and protocols, methods, and procedures? Consequently he has turned an exhibition into a school, a panel discussion into a trial and an information service into a publishing platform. The products (or effects, to borrow from Foucault again) of Vidokle's projects all point to exactly that: "Things can be different." This being "otherwise" even

01 MICHEL FOUCAULT, "WHAT IS CRITIQUE?" *THE POLITICS OF TRUTH*, ED. SYLVÈRE LOTRINGER (LOS ANGELES: SEMIOTEXT(E), 1997).

appears as a trademark of his. But rather than enter pre-existing institutions and other structures—as many curators did in Europe during the 1990s—he has gone in a different direction, one that appears typical of the 2000s, a decade marked by the resurgence of self-organized initiatives and methods of collaboration, often with artists who in turn collaborate with many other categories of people and who set up their own structures. They tend to seek self-determination. They are busy carving out space for maneuvering in a cultural and political climate where various forms of instrumentalization abound.

But let's turn for a moment to one of the beginnings. In 1998, two artists and a curator organized a one-night-only exhibition in a hotel room in New York's Chinatown. To avoid trouble, the hotel was given the impression that an audition was taking place, and towards the end of the night some hotel employees even came to try their luck. Being broke, the organizers could not afford to print invitations or even mail press releases. Instead they announced the project to friends and colleagues via the brand-new e-mail account of one of the artists, Anton Vidokle. That evening, many people came to see work by Michel Auder, Carsten Nicolai, Peter Scott, and Tomoko Takahashi.[02] It is in this unspectacular and incidental way that embryo of e-flux, one of the simplest, yet most influential contributions to the arts infrastructure in recent decades, was born.

In retrospect it seems self-evident; someone had to come up with the idea. We could even ask why no one did it before. And it should come as no surprise that it took artists to crack the nut. Unbeknownst to themselves, at least at the time, they had put their finger on both a need and a desire for distributing information within the international art scene. This was a moment when individualized global connectedness

02 HANS ULRICH OBRIST, ANTON VIDOKLE, AND JULIETA ARANDA, *EVER. EVER. EVER.* WWW.E-FLUX.COM/FILES/HANS_ULRICH_OBRIST_INTERVIEW.PDF.

was still in its infancy. There was a widespread sense that many interesting things were happening, particularly beyond the traditional centers, but it was hard to find information unless you had personal contacts or had traveled extensively. Some of this dispersion was all of a sudden gathered back together by a basic but efficient, immaterial electronic information service coupling a recent technological development with the desire to make information about art projects more readily available.

Shortly after the exhibition in Chinatown, artists Vidokle, Terence Gower, Josh Welber, and Adriana Arenas founded a company called e-flux. Today the company is owned and run by Vidokle and Julieta Aranda, also an artist. Then as now, art institutions, both public and private, could purchase access to a global network of receivers who, through an act of active subscription, are sent "announcements." e-flux still offers rates lower than ads in established art magazines and it continues to provide more facts than names, titles and contacts. e-flux announcements have a little more meat on their bones—albeit not more than a classical press release. On its website, e-flux is nowadays described as a "news digest" and it has two additional branches, Art-Agenda and Art&Education. Through e-flux's three announcements per day, subscribers find out about exhibition openings, museum inaugurations, calls for entries, job openings and many other things, no matter what goes on in the world and regardless of where we are. There is indeed a threshold for entries; not all institutions and organizations can afford the announcements. Yet being at the receiving end continues to be open to all and free. Although the three daily announcements can in no way be thought of as representative of the full range of activities in the world of contemporary art, they offer good coverage of certain things.

With e-flux, the New York–based artists crafted a service that has affected the way on which we learn about contemporary art and how

we deal with this information. At one and the same time, e-flux is a new format and a new infrastructure. In fact, e-flux can be thought of as something as rare as an invention, just as the art magazine and the biennial were once inventions in terms of what was distributed or displayed and how this was done. This can be seen as similar to the way shipping containers and pallets profoundly changed the infrastructure and logistics for the transportation of consumer goods. In doing this, e-flux also gave the press release, one of the stalest publicity formats in art, a new lease on life. Since its founding in 1999, e-flux has expanded the scope and range of its activities. Besides reaching over 50,000 subscribers daily, the organization now publishes books and a journal, organizes artist-centered projects such as *e-flux video rental* and *Martha Rosler Library* and occupies its second storefront space on the Lower East Side of Manhattan, where exhibitions, discussions and other projects take place.

All this is possible because e-flux is a profit-making enterprise, a feature distinguishing it from most artist-run spaces. e-flux has essentially become a financially independent structure controlled by artists, nowadays with a small number of employees. This has been a point of contention in the parts of the art world that think of themselves as "critical." Some discredit these activities as being too complicit with capitalism. One way of understanding the e-flux endeavor, beyond the invention, is as a quintessentially contemporary institution. It is an immaterial service that deals with the global circulation of information about art activities and as such, it is embedded in both the creative industries as well as post-Fordist conditions of production. Furthermore, the more event-oriented side of the art world is well-represented at e-flux, thereby lending visibility to the post-Fordist work. If today's role model for the artist is the entrepreneur, then the opposite is also true. The entrepreneurial has long been valued in most jobs; now the characteristics of the traditional artist lurk in many descriptions as well.

There is a sense of wholeness in e-flux and many other of Vidokle's works, a sense that they are "entities." His projects are "rounded-off." Within the framework of recent art history they are, paradoxically enough, not unlike Ilya Kabakov's "total installations," which are immensely complex and immersive fictions in three dimensions. e-flux is one of several projects initiated by Vidokle that can be framed as "institution building." It shares certain features with other long-term artist projects such as Rick Lowe's Project Row Houses in Houston, Rirkrit Tiravanija and Kamin Lertchaiprasert's The Land Foundation in Chiang Mai, Thailand, Per Hasselberg's Konsthall C in Stockholm and 16 Beaver in New York City, all of which function to some degree as institutions. A majority of them are self-sustaining, operate from a particular locality and are indebted to site-specificity and context-sensitivity as phenomena. In a way, the strategies of these organizations' initiators can be thought of as analogous to what a state, foundation, or wealthy patron would do, which is take self-appointed responsibility for setting up an organization that involves a considerable number of people and give it some sense of stability and continuity. It is indeed about "institution building," but in relation to a local context and a specific community, be it geographical, social, cultural, or other. We can even speak in terms of certain constituencies. However, e-flux's constituency is radically dispersed, and the office and project space could potentially be located in many other places.

The aspect of e-flux that emphasizes distribution and circulation of artistic and other intellectual material also calls for comparisons with a different set of "institutions." One of these is the independent publisher Semiotext(e), launched in 1974 by philosopher Sylvère Lotringer, which has been a key source of French theory in English-language translation. Another is the New York non-profit bookshop Printed Matter, founded in 1976 by artists and other cultural producers. The specialty bookshop Pro qm in Berlin, which opened in 1999, emphasizes participation in urban and artistic processes. Like e-flux, it is a place where

various functions meet and different interests, lifestyles, and ways of working intersect and are negotiated. The project-based research institute european institute for progressive cultural policies (eipcp) in Vienna comes to mind as yet another "institution" engaging in long-term investigations and knowledge production. In contrast to the former examples, eipcp lacks a space beyond an office, but makes up for this missing public face with a strong capacity for research. Its excellent website also allows for the mediation of specially commissioned texts in a number of languages. All of these examples combine production and exchange of new ideas with debates and concerns that reach beyond the world of art.

Vidokle's later work, specifically *unitednationsplaza* and *Night School*, partakes in yet another current within contemporary art, namely the "educational turn." Again, the setting up of a semi- or studio-institution is at the heart of the practice. In the wake of widespread discontent with established educational systems and other forms of knowledge production as well as their increasing integration into creative industries, numerous initiatives in various parts of the world have sprung up. These self-organized "institutions" deploy the terminology of schooling. Tania Bruguera's Cátedra Arte de Conducta in Havana, Lugar a Dudas in Cali, Colombia, Surasi Kusolwong's Invisible Academy in Bangkok (and sometimes other locations), Copenhagen Free University and the Exploding School in Copenhagen, Fritz Haeg's Sundown School-house in Los Angeles, Katerina Llanes' Sessions in New York City and Germantown, NY, and The School of Missing Studies in New York, Los Angeles and Amsterdam are only a few examples. Though radically different in terms of methodology, they share an engagement with self-organized knowledge production and move away from the didactic. The German word *Vermittlung*, or mediation, better describes their activities. It is worth pausing to note their disparate locations; this is truly a global phenomenon. If the "art in public space" genre appeared as a stagnant backwater of contemporary art in the 1990s,

one waiting to be discovered by more inventive people, "education" is today's equivalent: museum education, general programming around exhibitions and even the self-organized artistic initiatives deserve an infusion of creativity and fresh thinking.

As early as 1993, the art critic Douglas Crimp stated that the creative subject of modern aesthetics had been replaced by the institution as a theme and as object of deconstruction.[03] But what is an institution? Can these artist projects really qualify as institutions? Are they not too small and too volatile? The speech act philosopher John Searle wisely cautions against searching for an ontology of institutions.[04] Instead we should be attentive to "institutional facts," evidence of what the institution is and does. For that to happen, some form of collective assignment of function, be it from a person or a group, must take place. In turn, these people need to receive collective assignment of a certain status to be able to perform the first collective assignment at all. Furthermore, institutions then typically obey "constitutive rules," the kind which say that "X counts as Y in context C." Searle argues that education, religion, and science do not follow this equation and therefore cannot be called institutions. Money, property, and marriage do adhere to such constitutive rules however, as does language, the fundamental social institution. All of the projects listed above fit within Searle's definition of an institution—even more so if we take another of the philosopher's propositions seriously, namely that the purpose of human institutions is to create new forms of power relationships. This brings us back to Foucault and the definition of critique, to what happens when institutions and critique are attached to each other.

03 DOUGLAS CRIMP, ON THE MUSEUM'S RUINS (CAMBRIDGE, MA: THE MIT PRESS, 1993).

04 JOHN SEARLE, "WHAT IS AN INSTITUTION?" IN INSTITUTIONAL CRITIQUE AND AFTER, ED. JOHN C. WELCHMAN (ZURICH: JRPIRINGIER, 2006).

We could think of this "institution building" as a new phase within institutional critique. The first phase, famously described by Benjamin H. D. Buchloh as moving from the aesthetics of administration of Conceptual art to the administration of aesthetics, included work by Hans Haacke and Michael Asher among others. Fault-finding in institutions was the favored method, and it was conducted from a position ostensibly outside the institution. The dichotomy between the subject and object of critique could be kept intact. The phase that followed took subjectivity and identity into consideration in more elaborate ways, still pointing fingers at institutions, albeit now from within. Works from the late 1980s and early 1990s by Andrea Fraser and Fred Wilson are often evoked as examples. In the late 1990s yet another phase could be discerned, for instance in the work of Bik Van der Pol and Apolonija Sustersic, in which the artists entered a more constructive dialogue with institutions. Based on institutional problems or dilemmas, they proposed changes that sometimes operated with the institution and other times against it, but rather dialogically and without condemnation. The institution was not only the problem, but also became part of the solution. More recently, artists such as Marion von Osten and Carey Young have formulated a critique that could be framed as a fourth phase. Now it is the whole "institution of art," the apparatus itself that is being scrutinized and challenged, not least its economic side, again from within the belly of the beast.

The "institution builders" comprise a fifth phase of institutional critique within this scheme. This time, artists take a step sideways and initiate new entities. Compared to the previous waves, this form of critique is less direct, something that seems difficult to avoid if you set up your own project, whether in opposition to something existing, as an alternative, or simply as a parallel. Since the mid-1990s self-organization has, like institutional critique, once again become a force to be reckoned with, and both should be seen in light of the effects of neo-liberal economy on democracy. This flowering is a warning of sorts, a call

to arms. However, the withdrawal from the mainstream observable in this fifth phase does not celebrate separation as a virtue in and of itself but as a necessity of survival. Let's call it strategic separatism. Some of those affiliated with strategic separatism opt for less visibility, while others remain on the side but stay visible and accessible. Both deviate from the classical Enlightenment paradigm of critique as being based on, and striving for, transparency. Interestingly enough, this trope of flight and escape has its equivalent in contemporary philosophy and political theory, with Foucault's emancipatory "non-escapist terms of escape" as a prime example.

Even if institutional critique once was something of a new social movement within the art field, over the years it has become in many ways "an institution of critique." In other words, critique has become institutionalized. And yet it is worth pondering the relevance of institutional critique today. Is institutional critique merely a bacteria that has strengthened the mainstream art world's immune system?[05] If we broaden the horizon and remind ourselves of China's political system as a critique of capitalism, then it becomes clear that at least this critique has helped refine its very object. We have to ask if institutional critique, like multiculturalism, has become a tool for subordinating certain groups and interests.[06] Can we even see the symbolic integration of critique in cultural institutions as a parallel to the way critique has been absorbed and disarmed within the political system? The challenge seems to be to renew, and even reinvent, institutional critique.

A common denominator for *unitednationsplaza*, *Night School*, some of the manifestations of e-flux as well as most of the examples above

05 SIMON SHEIKH, "NOTES ON INSTITUTIONAL CRITIQUE," *ART AND CONTEMPORARY CRITICAL PRACTICE*, ED. GERALD RAUNIG AND GENE RAY (LONDON: MAYFLYBOOKS, 2009).

06 HITO STEYERL, "THE INSTITUTION OF CRITIQUE," *ART AND CONTEMPORARY CRITICAL PRACTICE*, ED. GERALD RAUNIG AND GENE RAY (LONDON: MAYFLYBOOKS, 2009).

is an emphasis on physical presence and even participation. They also tap into a widespread interest in the formation and functions of communities. Once again, we need to see this in light of the crisis of representative democracy and its increasing reliance on symbolic forms of participation. The thrust within contemporary art towards the literal and the palpable is intimately connected to a perceived desire for compensation. Not because it is more true or more genuine but because it allows for other forms of engagement. What is more, the physically palpable also increasingly appears in relation to the virtual as nature was to culture in the nineteenth century: something that is constantly referred to and argued with, like a shadow.

Gerald Raunig, a philosopher and co-founder of eipcp, has rightly pointed out that the discourse surrounding institutional critique in art has remained strangely insular, and has not been contextualized within larger cultural, social, or political critiques. His suggestion to move to "instituent practices," to the active making of new modes of working and coming together in various ways, including transversal ones, echoes the activities of the "institution builders."[07] Yet we face a fundamental dilemma, namely whether and how critique can be performed. Vidokle's projects are generally not cloaked in "critical" rhetoric. Instead, they simply offer structures and procedures that allow for something that differs from most of the dominant discourses and mainstream activities. This may end up being a wise choice: critique—like love and humor—suffers from the dilemma of enunciation. As soon as we say that we are going to be critical, or that we want to fall in love, or that a joke will be funny, the risk of it failing is immanent.

07 GERALD RAUNIG, "INSTITUENT PRACTICES: FLEEING, INSTITUTING, TRANSFORMING," *ART AND CONTEMPORARY CRITICAL PRACTICE*, ED. GERALD RAUNIG AND GENE RAY (LONDON: MAYFLYBOOKS, 2009).

MEDIA FARZIN
AN OPEN HISTORY OF THE EXHIBITION-AS-SCHOOL

"But… it's not finished yet," responded one reader to the first draft of this essay. It was a necessary reminder. I open with her words to emphasize that what follows is a provisional account of Anton Vidokle's exhibition-as-school, realized as *unitednationsplaza* in Berlin (2006–07) and Mexico City (2008) and as *Night School* in New York (2008–09). *Night School* held its last public seminar only months before this essay was written. Any attempt at writing its history or considering its implications, then, is contingent upon future developments and compromised by the very nature of the work as an open structure.

The exhibition-as-school insists on its status as an art exhibition stretched across a network of cities and authors. Some events were highly structured and self-reflexive; others were barely recognizable as "artworks." Initially a response to the problem of the international biennial and the object-based exhibition, the project went on to address the shortcomings of art's exhibition strategies, institutions, academies, and markets—and to posit itself as their alternative. The exhibition-as-school suggests a new means of bringing art and its publics together in a bid for artistic agency and as an attempt to construct the conditions under which such agency might be possible.

The exhibition that was to be an art school began with a failure. The idea was initially a curatorial proposal for the 2006 edition of Manifesta, the roaming biennial of European art. The event was to take place in Nicosia, Europe's only divided capital city, where Greek and Turkish Cypriots keep an uneasy peace on two sides of a demilitarized zone maintained by the United Nations. The curatorial team, comprised of Vidokle, Mai Abu ElDahab, and Florian Waldvogel, proposed to use the resources of Manifesta for an "exhibition as school," a temporary art academy modeled after the experimental programs of the Bauhaus and Black Mountain College.

Pedagogy was already something of an art world trope when the curators announced their proposal, but the lack of cultural infrastructure in Cyprus gave the intersection of art and education a new valence, turning a parachuting biennial into a response to local needs. Irit Rogoff, one of the more optimistic critics of the recent "educational turn" in art, sees the academy as a site of *potential*, both artistic and political: as "the site of a coming-together of the odd and unexpected—shared curiosities, shared subjectivities, shared sufferings, and shared passions congregate around the promise of a subject, an insight, a creative possibility."[01] Education, she suggests, can open a space for art to engage politically and ethically with the world, to enable collective projects while sidestepping essentialist, exclusionary mechanisms. "The whole point in coming together out of curiosity," writes Rogoff, "is to not have to come together out of identity."[02] The academy's potential community, which privileges curiosity over identity, spoke directly to the irresolvable political situation of Cyprus.

But irresolvable it remained, for in June 2006, only months before the opening of the biennial, Manifesta 6 was cancelled by the city of Nicosia. The curators' intention to hold events on both sides of the Green Line had apparently proved too much for the divided city. But failure may have been built into the proposal. For Rogoff, the educational model "must always include within it an element of fallibility—the possibility that acting will end in failure." Anselm Franke goes further, arguing that Manifesta 6 is a "ghost that haunts Europe,"[03] the legacy of the twin phantoms of colonialism and nationalism that are displaced by the spectacular glitter of so many European biennials. Manifesta 6 was a significant failure precisely because it refused to displace the conflict into an exhibition and bracket it as "art," because it uncovered

01 IRIT ROGOFF, "TURNING," E-FLUX JOURNAL 1 (DECEMBER 2008). HTTP://WWW.E-FLUX.COM/JOURNAL/VIEW/18.

02 ROGOFF, "TURNING."

03 ANSELM FRANKE, "THE GRUDGE," *PRINTED PROJECT* 6 (FEBRUARY 2007): 14–17.

Europe's very real territorial conflicts by attempting to work through them. For Franke, the biennial exhibition is a neocolonial "cultural entrepreneur that puts places like Nicosia 'on the map' without any adequate language to help him." The exhibition as school intended to foster the development of a language *in situ*, to acknowledge precisely these ghosts. But they would have to be dealt with elsewhere, in a city with its own history of dividing walls.

Franke's remarks were first presented during the inaugural conference of *unitednationsplaza*, which opened in October 2006 in Berlin. Organized by Vidokle and Tirdad Zolghadr, "Histories of Productive Failures: From French Revolution to Manifesta IV" was a three-day investigation on the subject of failure, drawing on the recent events in Nicosia and examining more general failures in the current state of the art academy. After the cancellation of Manifesta 6, Vidokle moved his "departments" and collaborators to Berlin, where the events were stretched out over a period of twelve months and re-titled *unitednationsplaza*, after the street on which their new site was located. *unp* took place in a rented space Vidokle procured in the former East Berlin to host the project and thereafter referred to as "the Building." Seminar leaders included those led by Liam Gillick, Boris Groys, Martha Rosler, Walid Raad, Jalal Toufic, Nikolaus Hirsch, Natascha Sadr Haghighian, and Tirdad Zolghadr, but its final event in 2007—marked by *Everything Must Go*, a sale organized by Vidokle and Rosler on the model of Rosler's "garage sales"—a cast of over sixty artists, theorists and writers had been involved in presentations and events at The Building.

From the very outset, *unp* and its use of The Building played with various aspects of institutional infrastructure. The project's name is a metonym for its oblique institutional maneuvers: an ostensibly literal translation of a street name, *unitednationsplaza*'s invocation of the UN's utopian aspirations for a postwar world order—and its history

of failing to meet them—are a highly appropriate frame of reference for the "ghost" of Manifesta 6 and its new home in Berlin. The renaming has its historic parallel: Platz der Vereinten Nationen was the name given to Leninplatz after the official narrative that upheld it fell apart. In a nod to this history, *unp*'s first seminar was Boris Groys' "After the Red Square," a two-week event during which scores of guest speakers reconsidered art in relation to socialist-communist traditions.

The Building's literal naming calls attention to its shifting institutional identity: impermanent, undefined, yet resolutely functional. The architects Nikolaus Hirsch and Michel Müller were invited to redesign the space as part of an investigation of "the ambivalent character of the contemporary art institution."[04] Their research resulted in a modular design for the seminar room, with white cube seating that could be reconfigured to accommodate different formats, from gallery to lecture hall to performance space. ("Remarkably uncomfortable," one participant commented.[05]) "Thus *unitednationsplaza* becomes a space in which institutional models are displayed,"[06] write the architects, emphasizing its status as both a flexible pedagogic model and actual public space. Hirsch doubled as pedagogue: his seminar on The Architecture of Education discussed "the potentials and limits for the creation of a critical collective space."[07]

The Building was composed of two main event spaces, a kitchen, an office and a basement: all were utilized for presentations and events, including the Salon Aleman, a collaborative undertaking/occasional bar in the basement run by several artists,[08] and *Martha Rosler Library*,

04 *UNITEDNATIONSPLAZA.ORG*, HTTP://WWW.UNITEDNATIONSPLAZA.ORG/EVENT_UPCOMING.HTML.

05 HADLEY+MAXWELL, "(FIND US AT THE KITCHEN DOOR) AT UNITEDNATIONSPLAZA," *FILLIP* 6 (SUMMER 2007), HTTP://FILLIP.CA/CONTENT/FIND-US-AT-THE-KITCHEN-DOOR-AT-UNITEDNATIONSPLAZA.

06 *UNITEDNATIONSPLAZA.ORG*.

07 *UNITEDNATIONSPLAZA.ORG*.

an e-flux project by Vidokle that traveled to The Building over the summer, inspiring its own series of events. Many of the talks were broadcast through WUNP, a live radio station instituted and programmed by neuroTransmitter (artists Angel Nevarez and Valerie Tevere). Activities at The Building were guided by individual creative projects entangled in its quasi-institutional structure. This is the small but crucial difference between *unp* and an official art institution: while *unp* aimed to create the conditions for an active public space, the institutional structure is only one of the methods and sites employed to that end. By invoking the educational model, *unp* set the scene for processes of engagement that privilege the discursive experiment over institutional coherence. "Schools," Vidokle notes, "are one of the few places left where experimentation is to some degree encouraged, where emphasis is supposedly on process and learning rather then than product."[09]

Neither school nor exhibition proper—though it laid claim to the ambitions of both—*unp* presented itself as a seminar/residency for investigating "the possibilities for artistic agency today."[10] Events were open and free of charge to all who could attend. The artists, scholars, critics, and curators invited to present their work were given free rein in their presentation formats. Many of *unp*'s discussions, screenings, and performances tested the audience's level of commitment: talks and events varied widely in format, length, and frequency, and several leaned towards the performative. In the short text "(Find Us at the Kitchen Door) at unitednationsplaza"[11] the artist duo

08 THE BAR WAS A COLLABORATIVE PROJECT BY JULIETA ARANDA, ETHAN BRECKENRIDGE, EDUARDO SARABIA, ANGEL NEVAREZ AND VALERIE TEVERE, DANNA VAJDA, WILLIE BRISCO, AND OTHERS.

09 ANTON VIDOKLE, "OPENING REMARKS," *NIGHT SCHOOL* AT THE NEW MUSEUM (JANUARY 31, 2008), WWW.NEWMUSEUM.ORG/.../ANTON_VIDOKLE_NIGHT_SCHOOL_OPENING_REMARKS.PDF.

10 *UNITEDNATIONSPLAZA.ORG*.

11 HADLEY+MAXWELL, OP. CIT.

Hadley+Maxwell describe the experience of attending *unp*. Toufic and Raad's seminars ran for three to four hours every night for twelve nights as they worked through two or three sentences of Toufic's writings at a time (the authors call this a "rare and memorable experience"). Gillick, on the other hand, "divided his performance between half-hour lectures (intentionally alienating and not-to-be-interrupted) and subsequent retreats to the bar in the cellar where he welcomed conversation. The clear laws of engagement put forward by this structure," they continue, "seemed to be a direct challenge to the *unp*." Challenges notwithstanding, Hadley+Maxwell found a great deal to celebrate in the "spirit of critical conviviality" posed by *unp*'s "deliberately open, theatrical format."

Two texts by Gillick, who was a participant in all four iterations of the project, suggest that his experience with *unp* transformed his own ideas about the art academy as an art project. In his essay for the Manifesta 6 reader *Notes for An Art School*,[12] Gillick reminds us of "an enormous shift in the role and potential of educational environments in relation to visual culture" in the past twenty years. Critical theory has taken over the art academy, with students and teachers required to describe their exact coordinates on the chessboard of art, even if their move is to reject critical positions altogether. And a great many artists have chosen precisely this path of rejection, to the detriment of the "semi-autonomous critical context."[13] There are possibilities, Gillick is implying, for critical theory as a practice undertaken by artists with the same seriousness as art historians and theorists. It is in *unp* that Gillick finds a promising "fourth stage educational environment" that allows him to consider, in a 2008 text, how a school might become an art project in itself: "The Vidokle model has binned the idea of

12 LIAM GILLICK, "DENIAL AND FUNCTION: A HISTORY OF DISENGAGEMENT IN RELATION TO TEACHING," *NOTES FOR AN ART SCHOOL* (AMSTERDAM: INTERNATIONAL FOUNDATION MANIFESTA, 2006), 46-51.

13 GILLICK, "DENIAL AND FUNCTION," 48.

integration and accommodation in favor of shifting a sense of engage-ment with educational structures—rapidly and completely—via the creation of new layers of interaction." *unp* is neither art school nor residency, but "a contingent, implicated model where modes of assessment and potential are freely negotiated."[14]

Not everyone, of course, negotiates freedom and potential in the same way. Gillick's free space of negotiation should be contrasted with the more skeptical judgment of Hadley+Maxwell, who were present during his *unp* presentations. The event gives them the occasion to describe the particular dynamic of seminars at *unp*, noting that the "anxiety around inclusion/exclusion, pervasive among all participants we have interviewed, is a reminder that there might be more cultural capital awarded to people who, for example, have a drink with Liam Gillick in the kitchen than attend a class with him in the seminar room."[15]

The kitchen was the anxious site of many an audience-artist tussle. Zolghadr's seminar on discursive formats, "That Is Why You Always Find Me in the Kitchen at Parties", included an evening organized by artist Chris Evans.[16] In planning the event's mise-en-scène, Evans looked to a historic precedent in the seminars held at the Nova Scotia College of Art and Design in the 1970s, which were often broadcast live into the school's cafeteria. Evans invited a group of Berlin-based

14 LIAM GILLICK, "THE FOURTH WAY," *ART MONTHLY* 320 (OCTOBER 2008): 6-7.

15 HADLEY+MAXWELL, OP. CIT.

16 ACCORDING TO HADLEY+MAXWELL, THE EVENT WAS BILLED AS *"DON'T KNOW IF I'VE EXPLAINED MYSELF. A SYMPOSIUM SET UP BY CHRIS EVANS (AFTER GARRY KENNEDY). 'THE ITALIAN EXPRESSION NON SO SE MI SONO SPIEGATO' SEEMS TO APOLOGIZE FOR THE SPEAKER'S LIMITED SKILLS, BUT IT IS ACTUALLY AN UNSOLICITED PAUSE, AN OPPORTUNITY TO RECAP AND SPECIFY.' ON ART WORLD DIVISIONS OF LABOR BETWEEN THE ARTISTIC AND THE DISCURSIVE. WITH MICHAEL BAERS, ANNIKA ERIKSSON AND OTHERS."* EVANS WAS NOT INITIALLY INTRODUCED AS THE ARTIST BEHIND THE WORK, ALLOWING HIM TO APPEAR INCOGNITO AMONG THE AUDIENCE MEMBERS IN THE SEMINAR ROOM.

artists to take part in a discussion of the artistic claims of *unp*, intending to have the conversation broadcast from the kitchen to the seminar room next door. But when the faulty sound system broke down (unbeknownst to the speakers in the kitchen) the audience formed their own discussion, went to buy their own beer and barricaded the performers in the kitchen with the modular seating cubes.

While the conventional classroom, like any public institution, rehearses the ideal of equal access for all, the flexible structure of *unp* pays no lip service to such democratic ideals. Gillick's seminar used the format of an artist talk to highlight the exclusionary mechanisms at work in such "public" presentations, while Evans' event isolated the audience and placed them in unexpectedly disadvantaged circumstances. Such discursive tactics set the stage for the audience to acknowledge its own position and stakes in the conversation and to make decisions about where it stood in relation to the conditions of production—as "passive" audience, or as "active" interlocutor? To participate or not?

The disgruntled and unpredictable responses to the artists' provocations may well demonstrate the potential of the educational model. The learning process is open to experimentation, but also to failure—failure not in its conventional sense, but as a not-doing. "One of the most interesting aspects of potentiality," writes Rogoff, "is that it is as much the potential for not doing as it is for doing." Her understanding of the notion of potentiality owes much to Giorgio Agamben, whom she quotes: "'To be potential means to be one's own lack, *to be in relation to one's own incapacity.*' …So thinking 'academy' as 'potentiality' is to think the possibilities of not doing, not making, not bringing into being at the very center of acts of thinking, making and doing."[17] In turning from an object-based production to a discourse-centered

17 IRIT ROGOFF, "ACADEMY AS POTENTIALITY," *ZEHAR/DOCUMENTA MAGAZINES ONLINE JOURNAL*, HTTP://MAGAZINES.DOCUMENTA.DE.

approach, the artist reserves the option to not do and not make. The audience, in their turn, is allowed the option to not engage, to not take part—or to envision a completely different way of engaging.

When Vidokle was commissioned to present his exhibition-as-school as an artist project at the New Museum in New York, its name was changed to *Night School*.[18] The project was incorporated into the Museum as Hub, "a new model for institutional practice and international collaboration"[19] that signaled the newly re-opened museum's intention to import discursive curatorial practices into the American context. There are many affinities between Vidokle's project and what has come to be referred to as "New Institutionalism." The term is a frequent touchstone in discussions of the self-reflexive and flexible approach to the relationship between art and the institution that was first taken up in the late 1990s by a number of independent curators in Europe.[20] New Institutions emphasize "fluidity, discursivity, participation and production,"[21] playing down the exhibition in favor of lectures, screenings, conferences, residencies and publications. As curator Charles Esche phrased it, the art space becomes "part-community center, part-laboratory and part-academy."[22]

18 IN CONTRAST, THE NAME WAS NOT CHANGED WHEN *UNITEDNATIONSPLAZA MEXICO DF* TOOK PLACE IN MEXICO CITY IN MARCH 2008, WITH SEMINARS COMPRESSED INTO DAILY EVENTS FOR A PERIOD OF ONE MONTH.

19 "MUSEUM AS HUB," NEWMUSEUM.ORG, HTTP://WWW.NEWMUSEUM.ORG/LEARN/MUSEUM_AS_HUB

20 NINA MÖNTMANN'S *ART AND ITS INSTITUTIONS: CURRENT CONFLICTS, CRITIQUE AND COLLABORATIONS* (BLACK DOG PUBLISHING: 2006) GIVES AN OVERVIEW OF THESE ACTIVITIES.

21 ALEX FARQUHARSON, "BUREAUX DE CHANGE," *FRIEZE* 101 (SEPTEMBER 2006), WWW.FRIEZE.COM/ISSUE/ARTICLE/BUREAUX_DE_CHANGE.

22 CHARLES ESCHE, QUOTED IN CLAIRE DOHERTY, "NEW INSTITUTIONALISM AND THE EXHIBITION AS SITUATION," *PROTECTIONS READER* (KUNSTHAUS GRAZ, 2006), WWW.SITUATIONS.ORG.UK/_UPLOADED_PDFS/NEWINSTITUTIONALISM.PDF.

Night School's year-long program of seminars included many of the same speakers as *unp*,[23] but the publicity material for the project was careful to emphasize Vidokle's authorial position behind the project. *Night School* was described as "an artist commission in the form of a temporary school" that used the museum "as a site to shape a critically engaged public through art discourse."[24] Each seminar took place over three evenings in the museum's auditorium, and one of them was scheduled to coincide with the museum's weekly free-admission night. The project's new title signals a departure from the utopian appropriation of *unp*'s name, and reflects the museum's codified structure and the institutional constraints of the American context.

Artist Natascha Sadr Haghighian, for example, proposed holding her conversations with Avery Gordon and Thomas Keenan at a neighboring branch of Whole Foods, aiming for "a necessary shift away from the secure and isolated situation of an auditorium to a more challenging place that incorporates the contradictions and incompatibilities of theory in everyday life."[25] The supermarket did not grant them permission however, highlighting the contradictions that motivated the proposal in the first place. The conversations did eventually take place in the supermarket but were recorded on microphones and filmed on a spy camera, then broadcast to the audience in the New Museum's

23 NIGHT SCHOOL INCLUDED PUBLIC SEMINARS LED BY HU FANG, ZHANG WEI, XU TAN, OKWUI ENWEZOR, PAUL CHAN, RIKRIT TIRAVANIJA, AND RAQS MEDIA COLLECTIVE (JEEBESH BAGCHI, MONICA NARULA, AND SHUDDHABRATA SENGUPTA).

24 "NIGHT SCHOOL: A PROJECT BY ANTON VIDOKLE, JANUARY 2008 – FEBRUARY 2009," NEWMUSEUM.ORG, HTTP://WWW.NEWMUSEUM.ORG/EVENT_SERIES/NIGHT_SCHOOL.

25 NATASHA SADR HAGHIGHIAN, "SLEEPWALKING IN A DIALECTICAL PICTURE PUZZLE, PART 1: A CONVERSATION WITH AVERY GORDON," *E-FLUX JOURNAL* 3 (FEBRUARY 2009) HTTP://WWW.E-FLUX.COM/JOURNAL/VIEW/20 AND "SLEEPWALKING IN A DIALECTICAL PICTURE PUZZLE, PART 2: A CONVERSATION WITH THOMAS KEENAN," *E-FLUX JOURNAL* 4 (APRIL 2009) HTTP://WWW.E-FLUX.COM/JOURNAL/VIEW/48.

auditorium where they were followed by live question-and-answer sessions with the artist and her guests.

The audience itself was partly organized in advance. Similar to the curatorial proposal for Manifesta's exhibition-as-school, *Night School* invited applications for a "core group" that would commit to attending all of the public lectures and to meeting with seminar leaders for private workshops. In this way, *Night School* would lay the groundwork for a "critically engaged public," a group of "cultural producers including visual artists, architects, writers, filmmakers, journalists, curators, composers, [and] performers"[26] that would potentially bring their own concerns and involvement to the proceedings.

According to Vidoke's opening remarks, *Night School* hoped to transform the audience of passive consumers into a "public" of "engaged citizen-subjects." An active public is one that recognizes its own stakes in the conversation. Inviting a core group of cultural producers certainly complicates the role of the spectator; the transformation of the audience into a public, however, is harder to ascertain and its success can only remain an open question. The exhibition-as-school refuses both the exhibition's market success and public reception and the academy's professional accreditations and long-term educational reputation. We are left with an open history and an artistic-institutional hybrid that hints at larger social and political significance: as "school," it promises a space to think about new forms of subjectivity, but as "exhibition" it offers a chance to embody those subject positions—to "congregate around the promise of a subject, an insight, a creative possibility."[27] But as Rogoff reminded me, the long-term fulfillment of these utopian ambitions, like the history of the project itself, remains contingent upon future developments. For the moment, we can only recognize

26 NIGHT SCHOOL APPLICATION, NEWMUSEUM.ORG.

27 IRIT ROGOFF, "TURNING."

the determination to open up a new set of options, both artistic and political.

It may be wiser to limit our reading to artistic criteria. Is the exhibition-as-school any different from its institutional and educational predecessors? Can it be read as a new form of exhibition- or art-making? New Institutionalism also aimed to complicate the traditional roles of institution, curator, artist and public, yet in many cases we find artworks that buttressed the institution, artists who incorporated "curating" or exhibition design into their work and curators who claimed to work "performatively"—while the institution renews itself, archives their work and continues with business as usual. Alternatively, the "new institution" itself was taken over by larger structures, had its curators replaced, or was closed because of budget gaps.[28]

Vidokle and his collaborators are aware of this history, and it is perhaps for this reason that he continues to claim independence from the museum structure and insist on the work's position as an artist commission, emphasizing the need to "do things in such a way that one does not completely rely on institutions for audience or funding, so that the work can also exist and circulate on its own, framed by itself."[29] e-flux, Vidokle's commercial announcement service, supports many of the artworks presented as "e-flux projects." *unitednationsplaza* and *Night School* propose the same kind of independence in their institutional position: "It can engage with an institution—as in this particular case with the New Museum through the Night School—yet it does not completely depend on institutions to manifest itself."[30] What sets *Night School* apart from its new institutional forebears is

28 SEE NINA MÖNTMANN, "THE RISE AND FALL OF NEW INSTITUTIONALISM: PERSPECTIVES ON A POSSI-

BLE FUTURE," EIPCP (2007) HTTP://EIPCP.NET/TRANSVERSAL/0407/MOENTMANN/EN .

29 VIDOKLE, "OPENING REMARKS."

30 VIDOKLE, "OPENING REMARKS."

this transitory engagement with the institution, or its aim of engaging with different audiences while maintaining a commitment to artistic agency for its collaborators. For in the final view, between the activation of the public and the agency of the artist, it is the latter that appears to be the more feasible proposition of Vidokle's ongoing "exhibition as school." The temporary nature of the projects and their provisional alliances with larger institutions seem to be the key to enabling this openness. Rather than turn the artist into a curator or organizer, it is Vidokle's commitment to being an artist that allows the structure to maintain its flexibility and possibility. We have moved away from New Institutionalism's "constructive critique"[31]; here, the artist actively claims its strategies while refusing to remain in their service:

IF AN ARTIST WERE TO DEVELOP A KIND OF PRACTICE REQUIRING A NEW INSTITUTIONAL CONFIGURATION IN ORDER TO MANIFEST ITSELF, IT WOULD SEEM POINTLESS TO TRY TO REFORM EXISTING STRUCTURES THROUGH CRITIQUE OR INFILTRATION—TO CHANGE THEM FROM WITHIN—SIMPLY BECAUSE THESE APPROACHES ONLY LEAD TO A RELATIONSHIP OF DEPENDENCY. AN ARTIST TODAY ASPIRES TO A CERTAIN SOVEREIGNTY, WHICH IMPLIES THAT IN ADDITION TO PRODUCING ART, ONE ALSO HAS TO PRODUCE THE CONDITIONS THAT ENABLE SUCH PRODUCTION AND ITS CHANNELS OF CIRCULATION. CONSEQUENT-LY, THE PRODUCTION OF THESE CONDITIONS CAN BECOME SO CRITICAL TO THE PRODUCTION OF WORK THAT IT ASSUMES THE SHAPE OF THE WORK ITSELF.[32]

If the necessary conditions for artistic experimentation, collaboration, and commitment demand a hybrid school, residency, and lecture series, then the artwork must take on the task of producing those conditions. For many artists, self-organized initiatives are a means of producing collaborative work or constituting a community of like-minded thinkers. Yet with the exhibition-as-school, we find a work that is invisible

31 THE TERM IS USED BY MARIA LIND TO DESCRIBE A COLLABORATIVE INTERPLAY BETWEEN CURATORIAL AND ARTISTIC PRACTICES. SEE MARIA LIND, "MODELS OF CRITICALITY," *CONTEXUALIZE* (KUNSTVEREIN HAMBURG, 2002), 150.

32 VIDOKLE, QUESTIONNAIRE RESPONSE, *OCTOBER* 129 (SUMMER 2009).

beyond those conditions, that claims *formal* artistic relevance for its own aspirations to artistic sovereignty.

One way of understanding this proposition is through Boris Groys' 2000 essay "On the New," which emphasizes the continued centrality of the art museum to the narratives that frame art. Whereas the modernist museum was a stable place, exemplified in "the idealized context of the universal museum," the art museum of our time—with its large-scale traveling exhibitions organized by international curators—is changing and unstable, constantly posing revisions to existing historic narratives.

SO THE STRATEGY OF CONTEMPORARY ART CONSISTS IN CREATING A SPECIFIC CONTEXT THAT CAN MAKE A CERTAIN FORM OR THING LOOK OTHER, NEW, AND INTERESTING—EVEN IF THIS FORM HAS ALREADY BEEN COLLECTED. TRADITIONAL ART WORKED ON THE LEVEL OF FORM. CONTEMPORARY ART WORKS ON THE LEVEL OF CONTEXT, FRAMEWORK, BACKGROUND, OR OF A NEW THEORETICAL INTERPRETATION.[33]

The new, in order to reveal its difference, must work on the level of the contextual and the discursive. While Groys does not pursue his argument beyond the museum, such art is already moving towards a more ambitious artistic model: of not merely reflecting but also creating its own conditions of reception, both in space (the institutional context) and in time (the historical and theoretical context). Art's discursive turn is thus a way of responding to its institutions, of maintaining a dialectical relationship. But the implications of this development exceed the museum: for if the new institution's structures of historical memory are temporal and shifting, that which is new and different must also be temporal and continuously shifting—even in its engagement with the institution.

33 BORIS GROYS, "ON THE NEW," IN *ART POWER* (CAMBRIDGE, MA: MIT PRESS, 2008), 23-43.

The unprecedented formal approach of the exhibition-as-school lies in its near invisibility within the artistic framework. Its complex and peripatetic structure of collaborators and participants seems to have swallowed up the institutional apparatus altogether, producing not only galleries, seminars, and archives but entire buildings—the social institution of art as a functioning readymade. Yet we are still within the historical narrative of art, and the dialectic relationship with the institution of art continues to frame the work. The site of production has extended the archive of historical memory outward, into a larger realm of social and political concerns. Far from being sovereignty carved from the margins, this is a bid for sovereignty that takes on the institution through a constantly shifting engagement with its discursive and institutional structures.

With thanks to Claire Bishop.

LIAM GILLICK
THE BINARY STADIUM
ANTON VIDOKLE, INTERMEDIARY OR LOCUS

The project is the work and it is enduringly isolated from the work. It is endlessly productive, but it is not yet possible to quantify this production or assess how it should or could be exchanged. There is one artist and it is his project. Maybe it is Anton Vidokle in this case. But also there is no project without the others. In fact the word *project* is not used. There is no proper terminology yet. Work, talk, event and, more often, thing. And the artist at the center, Anton Vidokle, would never claim that it is only his project/thing or only his work/thing. He is not at the center anyway. There is no center here. There may be some beginnings and an excess of becoming. What is produced is the free-flowing movement of ideas hampered only by the ability of the presenters to present and the varied visitors to listen. The artist in this case is both instigator and witness to the events, and he is (deliberately) lost during the moments of mediation. He cannot control or express or speak for the project as a whole; this is a sign of success. But he is the one who is responsible—a responsibility that is not related to the notion of possession and does not require self-representation. Questions of who speaks are of central importance. Who speaks? With what authority? How are things accounted for? And where can we establish new strands as they consolidate into a meta-critical mesh?

unitednationsplaza originated in Berlin as a corollary to an abandoned Manifesta 6 component that would have taken form as an neo-educational structure within the context of a large international biennale. Instigated and organized by Anton Vidokle in discussion with Boris Groys, Martha Rosler, Walid Raad, Jalal Toufic, Nikolaus Hirsch, Natascha Sadr Haghighian, Tirdad Zolghadr and myself, the project functioned for one year as a free school-like structure in the center of former East Berlin. This was followed by a truncated version in Mexico City and a mutant form known as *Night School* at the New Museum in New York. *unitednationsplaza*, when it worked well, produced presentation and disagreement with a semi–open door policy. An e-mail

list confirmed the timing of events and ensured the presence of some people. However, on many occasions participants just turned up. The *unitednationsplaza* structure was not intended to be a place for all activities. It welcomed theorists, curators, and artists, but did not expect anything specific to be produced. It is possible that the presence of a diverse group of cultural producers would make it necessary to limit this to a site of concrete production. But no limits were set. At times it was hard to distinguish modifications to the building from their potential to be understood as specific art components. *unitednationsplaza* occupied the contested space that emerged between traditional models of art education—one that encourages the supposedly smooth transition into operating as a fully-functional artistic persona and one that introduces students to the mediating structures that have developed alongside recent shifts in curatorial practice.

Art exists as a form of education and appropriates educational structures in order to describe new forms for the relationship between notional producers and recipients. There is an apparent meeting of interests here that can often be misunderstood. A mixture of intentions and desires has to be described. For the battle to control and shape the mediation of art, while not passive, is not easily taken apart; it can be hard to distinguish one model from another. First there is social pressure and a genuine desire on the part of large institutions to engage with broader audiences and decode the varied intentions and potential meanings of art. This is a desire expressed by their boards and a condition of the state funding that they require. Second, there is the structure of education departments that become self-sustaining career structures with their own dynamic and trajectory. Third, there are various artists and curators who have decided that it is no longer possible to stand aside while these previously-mentioned structures control the immediate, daily mediation of art and its varied histories.

A further crucial factor is the relationship between the way artists are educated and the modes of educational structuring they have begun to develop, disturb, and take over. By default this has exposed even more clearly the fact that the art education system we encounter today does not reflect the potential of cultural practice. The standard model of art education is based on the assumption that the best way to teach artists is by example—that there should be little structure beyond catering to the intentional requirements of the work and the psychological potential of the artist/student. This should be supplemented by a smattering of theory and discussion among students/artists about their work. Such a model is developed to the point where it can be expressed through various nuances and structural tics that allow minor differences between art schools to be amplified into precisely expressible disagreements. Yet similarities override these antagonisms: Each program creates artists well prepared to work alone, to develop a "style," and to articulate a position that defines them as subtly different from other superficially similar artists. Within this type of development there is little room to address the potential of the following: the mediation of art, group practice, activist engagement, critical writing, new curatorial methodology. There are exceptions, but these remain locked into standardized models and therefore remain frustrating at a structural level. Education in relation to artistic practice is a parallel zone of obligations, structures, and projections.

It is no longer enough that every major exhibition should have its own educational program; today, art education has become a semi-autonomous project in its own right. For at least fifteen years, the notion that artists need an individual space, need to be taught by older artists, and need to produce degree exhibitions as an introduction to a broader community of singular practitioners has been insufficient to describe the increasing complexity and non-resolvability of the art context. For those who would prefer art to speak for itself, the desire to avoid mediating structures can only be achieved through

the abrogation of responsibility for expressing what cannot exist within the work itself and the takeover of that role by others. The notion of ceding control is central to much artistic practice, but the expression of that abandonment will find itself expressed at some point, assuming that the work or the artist is at any moment exhibited, discussed, collected, viewed, or displayed in any form or location.

In the context of the educational environment, there is a unique inversion of the future that can described. In the future you will always be an artist unless you can escape back to what you were before or forward into a parallel zone of cultural production. But the default position is to be an artist permanently. You could have attended art school for only one year and then spent the rest of your life working in a factory or a bodega or anywhere, but unless you enter into another identified structural role, you'll always remain an artist while fulfilling other specific jobs or social functions. In standard educational environment there are people who will wear something else to see how it fits. The university offers a brief moment during which they can turn "I used to be someone else" into a meaningful structure that can allow for some side-stepping and future evacuation. This is in order to suspend the moment of infinite projection of potential that will emerge—directly related to the shifting of identity and identification that comes with the educational markers that attend art. That's the regime in which people are operating: they either accept the notion of infinite projection or retain an evacuation route. Vidokle has recognized that this is not enough because it's too vague or vulnerable. Infinite projections—he or she could be good, something could happen, maybe you won't be functional, or maybe things will work themselves out in other, more pragmatic ways. Vidokle's notion of displacement brings us closer to a functional reality. There are no infinite projections, no groups of people validated by the clause that they used to be or could have been something else at some point. I used to be funny, I used to be a punk, I used to be a filmmaker, I used to be a genius.

I'm now seeing how it might be possible to engage in a discourse in order to proceed.

In the past, revised models of education were often predicated upon the take-over of departmental direction or the creation of new rigors. The Vidokle model has done away with the integration and accommodation this implies and instead shifts the engagement with educational structures—rapidly and completely—to new forms of interaction. Vidokle does not replace what exists, but rather supplements and problematizes the way developed art education is organized and expressed. We are in the midst of a period during which the alternative education structure should take over the dynamic terrain of educational "production" in the same way that autonomous independent art initiatives have usurped established exhibiting institutions. Some younger practitioners have already opted to skip the standard trajectory of art education in favor of a contingent, implicated model in which modes of assessment and potential are more freely negotiated.

There are limited ways out. You can be professional and this is one way. You can set yourself into a context where you deal only with people who think you are functional. This is also a good option. You can become something else, you can make movies, or you might build buildings, or do something else under the umbrella of the art context. Life would be much easier if we went and did social research— anthropology or something like it. The structure is always underscored by questions: Where do we draw the line? What is to be done?

unitednationsplaza exposed an interest in parallel positions that forefront discursive potential. It did not pin down the way people should function in an art context, which brings us to why I discussed Volvo during my *unitednationsplaza* presentation. Having broken down a certain degree of Taylorist analysis and been given a degree of autonomy, the people involved in *unitednationsplaza* would spend a lot of time creating time

to talk. And what they tended to talk about is how to work faster so they had more time to talk … about how to work faster. The whole thing created a discursive crisis of freedom. Within *unitednationsplaza* it was possible to expose such parallel narratives of projection and consolidation.

unitednationsplaza intermittently reassessed the temporal scale. It set up revised notions of projection in order to prevent at least two things. One is the hyper-utopianization of any progressive thought (which is always a problem). Vidokle's project fought the notion that anyone who thinks about what to do and how things could be better operates within the realm of the utopian via the contingencies of every day. Secondly, *unitednationsplaza* addressed "What should we do tomorrow?" These two functions, rejection and affirmation, are crucial for finding the gap between utopian dismissal and "What should we do tomorrow?" The most interesting space lies between these two coordinates. It's where you'll find components of cultural "movement" that have little to do with classical ideas of representation or how you might be feeling or what's going on "outside," but without losing the precise connection to other people in other situations. Yet this connection does not set up a dichotomy—them and us.

This might be a good time to mention Andrei Arsenyevich Tarkovsky's film *Solaris*, and its description of a place where people reanimate others who remain alive again just long enough to realize what's going on before dying a second time in front of their loved ones. They reanimate and then they die, they reanimate and then they die. Think about this in relation to *unitednationsplaza* and we have a whole other way to reveal what might be interesting. It implies a problematic relationship to the idea of them and us. The notion of education beyond worrying about "What they will think?" or "How will they respond?" or "Will they understand?" A football stadium is not a football stadium when you're herding people into it to break their fingers prior to

finishing them off. It is a site of execution. Functional definitions are not stable, they have no inherent value, no fundamental meaning. A church when a massacre is taking place is not a church—it is a venue for hyperbolic destruction. States are not sound and permanently valid. But they will always bear traces of and relationships to their abuse, and to sterility. They are laden with potential for a new structural model unhindered by a normative progression of cultural identification.

MONIKA SZEWCZYK
ANTON VIDOKLE AND THE ANAESTHICS OF ADMINISTRATION

I will try to make some sense of a comrade who has been increasingly associated with the so-called "discursive turn" in art through projects such as *unitednationsplaza*, *Night School*, and *The New York Conversations*.[01] Yet my overwhelming impression is that of an artist who is rarely the one to speak. Indeed, most often when I see Anton Vidokle at an event he has (co-)organized, he is hanging back, off-stage, taking things in like the rest of the audience. Observing him observing, I think of a painter stepping back to examine a canvas—that crucial moment of confrontation when you compare what is in your mind against the composition in process before you. This moment is all-important, but often missed in readings of Velazquez's *Las Meninas* (1656). One of the greatest paintings ever made shows the artist stepping away from his creation; and, crucially, this takes place at that moment when absolute sovereignty appears: the king and queen reflected in the mirror behind him are figureheads of the regime of his day. He steps back and watches, like the rest of the court, and they all see each other. This may mean a lot of things, but (as Foucault tells us) chief among them is the recognition of a certain order of things.

Why envision one of the greatest paintings ever made as depicting the moment of stepping back from a painting, when artist and others are somehow *en par*, taking in the scene they create together? Indeed, this comparison might baffle Vidokle as well as several of his collaborators who we might call the painting skeptics. Think of Rirkrit Tiravanija's beautiful reversal of the late painter Peter Cain's note to self in *Less Oil More Courage* (2007–).[02] At least in part, Cain's

01 THE NEW YORK CONVERSATIONS, MY FIRST COLLABORATION WITH VIDOKLE, WAS A THREE-DAY EVENT (OF CONVERSATION AND FOOD) IN THE SUMMER OF 2008, CO-ORGANIZED BY THREE "FEATURED ARTISTS" OF THE JOURNAL *A PRIOR*. THE EDITORS, INCLUDING ELS ROELANDT, ANDREA WIARDA, DIETER ROELSTRAETE, ANDERS KREUGER AND MYSELF, CONCEIVED THE EVENT AS AN ISSUE OF THE JOURNAL WITH VIDOKLE, NICO DOCKX, AND RIRKRIT TIRAVANIJA. VIDOKLE PLAYED HOST IN HIS NEWLY OPENED E-FLUX SPACE ON ESSEX STREET IN NEW YORK.

reversed memo could also be interpreted as an anti-painting slogan: at a moment when the market for painting is booming, it doesn't take much courage to spill more oil on canvas. It must be said, though, that Tiravanija's stakes are higher. His text gains additional force through its clear reference to the political economy of the War on Terror, a politics of fear desperately attempting to capitalize on oil-driven economies. Broadly speaking, the problem for artists involves worrying about pursuing politically consequential acts and attitudes in the face of a regime gone wrong. What I am trying to unpack is the way in which aesthetics plays into this problem and whether art is its province. And keeping in the back of our mind the strange subjects of Velázquez painting—*Las Meninas* means the maids of honor, but essentially they are servants—I will venture a thought or two on what Vidokle's particular aesthetic serves.

<p style="text-align:center">*</p>

Perhaps the question asked most often of Vidokle is whether he is actually an artist. He has the papers to prove it and he rather emphatically insists that what he does, which encompasses a broad range of necessarily collaborative activities, is art. But people remain skeptical or curious about the implications of his stance. Part of the problem is this: what good are papers when your tendency is to bypass institutions altogether and create your own? (More on this soon.) Or, to put it another way, what is the point in insisting that what you do is art rather than simply calling it, say, a "necessarily collaborative activity"?

Boris Groys has demonstrated a logical link between such a nominal stance and the particular, Christ-like status of the Duchampian readymade. In his essay "On the New," he recalls Kierkegaard's distilling of Christianity to "the impossibility of recognizing Christ as God—the

02 SEE THE TEXT WRITTEN BY TIRAVANIJA ON THE OCCASION OF HIS EPONYMOUS EXHIBITION AT THE FRIDERICIANUM IN KASSEL: HTTP://WWW.FRIDERICIANUM-KASSEL.DE/TIRAVANIJA.HTML?&L=1.

03 BORIS GROYS, "ON THE NEW," IN *ART POWER* (CAMBRIDGE, MA: THE MIT PRESS, 2008), 23–42.

impossibility of recognizing Christ as *different*."[03] Similarly, the ready-made introduces a kind of Kierkegaardian "difference *beyond* difference" among the world of things, which raises the problem of how the new manifests itself. How can we tell something or someone is different and new if it, he, or she behaves like everything or everyone else? For Groys, the answer lies in context. The institution of the museum delimits what is old in art, what has been done, while the truly new is alive like everything and everyone else in life. Hence, Duchamp's work depends on the frame of the museum. Even still, this leaves us with a niggling question: What is a readymade *outside* of the museum, the gallery, the collection? The museum as framing device points to the fact that, while much is made of Duchamp rejecting painting in favor of the ready-made, this conversion can only be upheld if we willfully reject Derrida's position that the "truth in painting" lies in the simple fact of it having a frame, that device that separates the world of the image from the rest of the world. Following Derrida, we might see Duchamp expressing the truth in painting rather than rejecting it outright. His practice is a checkmate of painting that crowns the frame king. For Derrida, the frame is a *parergon*—all that exists beside [*par*] the work [*ergon*], which in fact constitutes the work.[04]

But in some ways all of this is "beside the point" when looking at Anton Vidokle's work, though we should not dismiss it outright. This "beside" may prove to be rather important yet. Vidokle is not quite like the Duchamp who creates the readymade in that, rather than relying on the existing institutional frame to sanctify his work, he constructs his own, qualitatively different institutions. These tend to make the existing institutions matter *more*, since e-flux's increasingly broad channels allow them to reach a broad audience, one that is encouraged to

04 JACQUES DERRIDA, *THE TRUTH IN PAINTING* (CHICAGO, IL: THE UNIVERSITY OF CHICAGO PRESS, 1998). THE FRAME SHOULD BE UNDERSTOOD IN THE EXPANDED SENSE, AS IN "THE INSTITUTIONAL FRAME."

correspond and converse. His (and Julieta Aranda's) institution is fundamentally a network.[05] Yet, while e-flux began largely as a means for other institutions to publish their plans and propaganda, this network's horizon goes beyond advertising.

To be sure, part of the idea is the more efficient administration of information. And in this sense, e-flux continues a tradition of partly practical artist-run initiatives such as Claes Oldenburg's *The Store* (1961) or Gordon Matta-Clark's *Food* (1971–74), which distributed (art) objects or nutrition but were predicated on the belief that—as art projects—these quasi-commercial enterprises, with their pragmatic, self-preserving notion of profit, would also allow other things to happen. What makes e-flux unique is that its commodity is information—a strange thing that is only precious when it is organized, because there is in fact a giant surplus of the stuff. While information proliferates at an unmanageable rate on the internet, you could still argue that there is a scarcity of good (i.e., usable) information today just as there is a scarcity of good (i.e., edible) food, but only if you acknowledge in the same breath that the problem rests not in general availability but in distribution. And the problem of distribution is often a problem of packaging: today there is a scarcity of good frames for information, a problem of classification.[06] While artist-run institutions have too often become subsumed by government funding or the for-profit tactics of commercial galleries and other distribution enterprises, e-flux continues because it has invented a system of distribution for something with an as-yet-uncertain

05 IN THIS SENSE, VIDOKLE IS PERHAPS MOST LIKE THE DUCHAMP WHO CREATED THE SOCIÉTÉ ANO-NYME WITH KATHERINE DREIER IN NEW YORK IN THE 1920S TO BRING MODERNISM TO THE UNITED STATES, THOUGH DUCHAMP TOYED MORE WITH THE LEGITIMACY OF HIS SOCIETY THROUGH VARIOUS OFFICIAL-LOOKING ACCESSORIES SUCH AS STATIONERY AND STAMPS.

06 AND THIS PROBLEM IS MORE AESTHETIC AND MORAL RATHER THAN TECHNICAL OR EVEN LOGICAL. THE NOTION OF "GOOD" IS NOT SO MUCH DEFINED BY TOO MANY PARTIES, BUT RATHER BY TOO FEW. IT IS, FOR INSTANCE, RATHER TABOO IN ART DISCOURSE.

commodity status. People buy into the network, but it is a little unclear what one is really buying. In that, e-flux is a most interesting administrative enterprise. It is a thing that we continually step back from and proverbially squint at.

<p style="text-align:center">*</p>

In his seminal 1990 essay "Conceptual Art 1962–1969: From the Aesthetics of Administration to the Critique of Institutions," Benjamin H. D. Buchloh looks to the "interest" or the "the currency" of the historical questioning of conceptual art, "i.e. the motivation to rediscover Conceptual Art from the vantage point of the late 1980s: the dialectic that links Conceptual Art, as the most rigorous elimination of visuality and traditional definitions of representation, to this decade of a rather violent restoration of traditional artistic forms and procedures of production."[07] In elaborating the stakes of his historical enterprise, Buchloh traces the emergence of language on the picture plane "for the first time in the history of modernist painting" to cubism, then proceeds to categorize conceptual art as an attempt to "replace the object of spatial and perceptual experience by linguistic definition alone (the work as analytic proposition)." This, for him, is "an assault on the status of the object: its visuality, its commodity status, and its form of distribution."

Buchloh historicizes this project as the first to fully process Duchamp's legacy and the implication of "the death of the author." The analysis highlights, but ultimately rejects, the dogmatic refusal (aired by Joseph Kosuth) to align art with "work" in favor of the consideration of art as "proposition," as idea. The political implications of this denigration of work are huge, and Buchloh rightly seeks traces of labor in proto-conceptualism. He delineates the transformation of the work of art from a purely visual thing with traces of its own making to something that is both seen *and* read, and that does not necessarily require

07 ALL QUOTES ARE FROM BENJAMIN H.D. BUCHLOH, "CONCEPTUAL ART 1962–1969: FROM THE AESTHETICS OF ADMINISTRATION TO THE CRITIQUE OF INSTITUTIONS," *OCTOBER* 55 (WINTER, 1990): 105–143.

touch. For part of the essay, the proto-conceptual work is necessarily conflicted, oscillating between these polarities of image and text, and under great pressure from the administrative tautologies that would link it to capitalist productivity. It makes use of the most complex theories of language as a rub against the grain of visuality. Buchloh's paradigmatic example is Robert Morris' *Box with the sound of its own making* (1961), which is synaesthetic, nominal and links object to process. This allows Buchloh to describe the legacy of the ready-made not as one of pure nominalism but as the institution of a require-ment of administrative handling to uphold the simple power of nomination exercised by Duchamp. His is a slightly different version of Boris Groys' argument in which the artist's pronouncement is tan-tamount to law, albeit one that is almost God-given and therefore irra-tional. Buchloh instead posits the replacement of seeing and sensing that act with legal paraphernalia as rational proof of the artwork's separation from the rest of the world:

BEGINNING WITH THE READYMADE, THE WORK OF ART HAD BECOME THE ULTIMATE SUBJECT OF A LEGAL DEFINITION AND THE RESULT OF INSTITUTIONAL VALIDATION. IN THE ABSENCE OF ANY SPECIFI-CALLY VISUAL QUALITIES AND DUE TO THE MANIFEST LACK OF ANY (ARTISTIC) MANUAL COMPETENCE AS A CRITERION OF DISTINCTION, ALL THE TRADITIONAL CRITERIA OF AESTHETIC JUDGMENT—OF TASTE AND OF CONNOISSEURSHIP—HAVE BEEN PROGRAMMATICALLY VOIDED. THE RESULT OF THIS IS THAT THE DEFINITION OF THE AESTHETIC BECOMES ON THE ONE HAND A MATTER OF LINGUISTIC CONVENTION AND ON THE OTHER THE FUNCTION OF BOTH A LEGAL CONTRACT AND AN INSTITUTIONAL DISCOURSE (A DISCOURSE OF POWER RATHER THAN TASTE).[08]

08 BUCHLOH, 118. FOR BUCHLOH, THE MATTER-OF-FACT "LEGALISTIC LANGUAGE AND AN ADMINISTRATIVE STYLE OF MATERIAL PRESENTATION" CHARACTERIZE THE AESTHETICS OF ADMINISTRATION—HIS EXAMPLES ARE DUCHAMP'S USE OF THE NOTARY AND PIERO MANZONI'S ISSUING OF CERTIFICATES. TODAY WE MIGHT EXTEND HIS LOGIC TO CONSIDER THE ELABORATE ORAL TRANSACTIONS THAT ACCOMPANY TINO SEHGAL'S ART, WHICH RECAL THE LEGAL SYSTEM OF THE NOTARY IN MUCH MORE EMPHATIC WAYS. FOR BUCHLOH, SUCH STRATEGIES FAIL WHEN THEY ATTEMPT TO POLICE AESTHETIC JUDGMENT, BUT (ESPECIALLY WHEN I THINK OF MANZONI) I THINK THAT BUCHLOH IS LOOKING AT THE WORK TOO RATIONALLY.

In calling what he does art, despite skepticism from many in the public, does Anton Vidokle continue certain administrative legacies delimited by Buchloh? My sense is not that of the aesthetics of administration, precisely because one of the distinguishing features of Vidokle's work is his general disregard for the paraphernalia around his day-to-day praxis that might "legalize" it as art according to the law of precedents. Rather, Vidokle's functional approach to various bits of business hints at a kind of *anaesthetics of administration*. This is to say that administration is not the key operation—art is not the administration of aesthetic experience. And there are better ways to use administration. (Although there may be a need for more writing this anaesthetics—about what it means to put the focus on administration in art, especially as institutional critique, to sleep.)

There is something very efficient and matter-of-fact about e-flux. The enterprise does not draw attention to its own structure or fetishize its business proceedings. In fact, Vidokle does not like to discuss these subjects. Of course, it remains a source of fascination and a point of irritation for people who would like to believe that, to call it art, e-flux cannot be profitable, cannot be the institution of its own legitimation, cannot produce value in the given culture, cannot simply call itself art without acceptable "proof" before the court. That said, as a business, e-flux has a beautiful simplicity: the sale of announcements—each an image/text presentation of a project or an idea—makes other projects such as libraries (*Martha Rosler Library*, *e-flux video rental*), schools (*unitednationsplaza*, *Night School*) and, most recently, the *e-flux journal* possible. Autonomy over tautology. Most e-flux projects are predicated on the simplified (i.e. uncomplicated by current administrative structures) distribution of increasingly complex projects and ideas to a growing network comprised of individuals and institutions of varying commitment. To me, this touches on the fact that aesthetics is not the sole purview of art. More on this soon.

For the moment, let's consider how e-flux is or is not a form of institutional critique. For all the facilitating of the better work of other institutions, e-flux increasingly aims to be something not necessarily different or dissonant for its own sake, but better. What is the horizon of *unitednationsplaza* but a better school, even an alternate university? What is the horizon of *e-flux journal*, but a better *Artforum* or *frieze*[09] (reaching more people, saving more trees)? What is the horizon of the e-flux announcement, but better advertising?[10] The entire enterprise is a prime example of a selective shift in our times—let's say since the 1990s—from the notion of institutional critique to notions of renovation and repurposing, a shift that morphs modernism (with its dialectic of destruction/reconstruction as a continual production of the new) into something we might call renovation. This model of progress may be read as conservative (we don't want things to change so we will *appear* to change while staying essentially the same) or as anti-symbolic (distrustful of the decisive appearance of change as constituting real change, let alone improvement). Whatever the name, it happens at an uncertain pace.

And I'm not sure this should be given a name. Liam Gillick, a close collaborator of Vidokle, tends to capture the unnamability of what is afoot. Gillick very often deploys double entendres ("Everything Good

09 A RECENT ADVERTISEMENT CAMPAIGN BY E-FLUX JOURNAL IN VARIOUS LEADING ART PUBLICATIONS INVOLVES PUBLISHING LARGE CHUNKS OF COMMISSIONED ESSAYS THAT (TO BE READ IN THEIR ENTIRETY) REQUIRE THE PURCHASE, OR CONSULTATION, OF MORE THAN ONE SUCH JOURNAL. THIS BOTH STIMULATES DEMAND FOR THE JOURNAL HOSTING THE ADVERTISEMENT AND PROVOKES QUESTIONS ABOUT THE LACUNAS OF CONTENT AND OF GOOD (INFORMATIVE) ADVERTISING.

10 THIS, OF COURSE, CUTS AGAINST THE GRAIN OF THE NOTION OF "GOOD" ADVERTISING AS SOMETHING THAT IS INSTANTLY PERCEPTIBLE. WHAT E-FLUX PROVIDES IS THE ADVANTAGE OF THE LOOSER SPATIAL CONSTRAINTS AFFORDED BY THE INTERNET, WHICH MAY FACILITATE MORE FULLY-FORMED THOUGHTS RATHER THAN MERE SLOGANS. THIS OF COURSE IS A POTENTIAL CONDITION.

Goes") or woozy, Deleuzian terminology such as "anyspacewhatever" or the "superwhatnot." This tends to irritate people who prefer symbols to real, albeit invisible, change, or those who argue that erecting a symbol is the first step toward making that change. Lawrence Weiner is another artist who insists on using language to make a statement, more like a sculpture makes a statement and not like a critic makes a statement (he has a clear disdain for critics). Another name for this is poetry—un-ruly language.

Back to Buchloh's essay, which is the key to my thinking about Vidokle—at least in the sense that it hints negatively at the fundamental anarchy of the aesthetic as well as the fundamental problems of a stance that tries to set rules for this strange category of judgment. Aesthetics is a weird science, one that came to the fore during the Enlightenment as an appendage to rational procedures that seek to administer the mind more strictly. Sol LeWitt claims this surplus status in his *Sentences on Conceptual Art* when he states, "Conceptual artists are mystics rather than rationalists. They leap to conclusions that logic cannot reach." If Vidokle is someone who similarly does not rush to administer the aesthetic, I stop short of considering him a mystic (or a conceptual artist, for that matter). But I might venture to consider him alongside the man of letters Alain Badiou describes in his *Saint Paul: The Foundations of Universalism*: a figure interesting not because of his mysticism but because of his novel organization of an *ekklesia*. This term is something that Paul, the Roman citizen who speaks the simple Greek of travelers and merchants, would have understood, after *ek* ("from" or "out of") + *kaleo* ("to call"), as a company of people called and thus not yet a root for the normative institution of the church.[11] Paul's *ekklesia* is something of a network based on announcement (in his case, letters and epistles). Badiou argues that he does not fully believe in God or Jesus or miracles (he does not look for "signs" like the apostles), but is interested in creating connections with just about every nation in his world. Vidokle does not serve such

a political cause, but he does recognize the power of the announcement. So much so that its transmission has become part of his art.

<center>*</center>

"I believe in the network," a good friend recently told me. The first words that came to my mind, not voiced, were: "What the *hell* is that supposed to mean?!" My automatic impulse had been to substitute "network" with "God," the other entity most often used in its place in that sentence, and I found myself in a in territory that makes me cringe. Then I thought: *Is not the cringe one of the clearest aesthetic experiences?* I had not really thought of the network as an object of belief, though I'll admit that I have believed in the power of aesthetics, for a long time even as thinkers I respect scoff at such outdated, conservative lingo. The problem of aesthetic judgment lies in its relations to subjectivity and universality. What is the subject of aesthetics? And what is the universal truth governing this odd experience combining thought and feeling, perception and action? I have held fast to aesthetics as the thing that enlivens perception and action, something capable of producing a (sometimes shared) sense of subjectivity and universality—without being able to determine them.

And as I am not an artist, I also think that aesthetics is not something art can take as its province or administer. There is a relationship between art and aesthetics: you could say that artists work on, work out, or work through an aesthetic (or more), just like everybody else. Unlike Plato, who wanted to ban artists from the Republic for falsifying things, we now tend to think that the artist's work helps to clarify aesthetics, might allow us to see more clearly how things are and how things might be. (An extreme case of this guidance can be found in Michel Houellebecq's *The Possibility of an Island*, where a Duchampian artist becomes high priest of a new life.) Critics, like Buchloh and maybe

11 ALAIN BADIOU, *SAINT PAUL: THE FOUNDATION OF UNIVERSALISM*, TRANS. RAY BRASSIER (PALO ALTO, CA: STANFORD UNIVERSITY PRESS, 2003).

also Houellebecq, tend to step into the work of artists and mediate, but they are too often accused of bending things or closing off artists' work rather than opening it to more possibility. At times I think the problem lies more in our inability to ascribe critics an aesthetic of their own. Because of my all-too-liberal education, I'm always weary of calling myself anything. Writer or editor has an okay ring to it poet would be even better, bookmaker also feels good—but not really artist, perhaps because what I work on is what I consider to be the (at least partial) separation of art from aesthetics, so that aesthetics can be the universal domain for negotiating life.

Art is quite clearly the one thing that Vidokle believes in. Another, I think, is the potential of the network. I recently asked him what he thought of aesthetics, given the fact that he was rather disappointed with the cover of the *A Prior* issue that resulted from *The New York Conversations* (the reason, ironically, was that it looked too arty, especially the participants' handwritten signatures on the cover). But he did not answer then and there. Instead, his response came in the form of a film that presents the event differently. Simply described, it is a series of visual vignettes showing a protracted conversation between various protagonists. The dialogue meandered for three days around the (often precarious) economic and ideological conditions of production mostly, but not exclusively, in the realm of art. It is filmed in black and white on 16-mm film and subtitled from the transcripts. Notably, all text in Vidokle's film is generic, practical, sans-serif stuff. It thus repudiates not so much the journal (which, after all, organized the transcriptions) as it does the frame chosen by the editors. More work was done on the transcripts for Vidokle's film. The images, some of which had been filmed during the event, were added to after the fact though it is sometimes difficult to tell which is which. This difficulty—this difference beyond difference—remains crucial.

Another key element emerges. Visually, Vidokle's film lingers on the *parergon* of the proceedings—the shopping for and preparation of the food, the set up and the clean up (which is where we see him hauling boxes and washing dishes), the street, the e-flux space, furniture. The images are active in at least two ways. They are loving, as in a shot of a chair that seems to say: "Look how simple and beautiful this functional, modern thing is; it has facilitated many a good thought." And they are truly false, since the black-and-white image cannot document certain aspects of the event. It gives everyone that fabulous look (in every sense of the word) of coming from another time. Indeed, the subtraction of color accentuates the fact that something else has also been turned down—namely, the synched sound. The talk, which was taped, appears as subtitles. This makes *The New York Conversations* look like a foreign film but also brings into play the text/image split that was key to that difficult-to-administer strain of proto-conceptualism, interested in making something to be looked at *and* read. Turning down the sound does call attention to the fact that picture and speech/text do not obey each other's laws, even as they co-exist. Having been there, I would say that everything was different from what Vidokle shows us, though he shows us more of what it could have been. He distills what was said into his personal testament. And here, perhaps, his greatest intervention is the music (developed in collaboration with Christian Manzutto), which partly fills the void opened by the lack of diegetic sound and allows you to digest image and text differently.

All of the music is by Morton Feldman. This does something very special to my perception of Vidokle's film, as I love to write with Feldman playing in the background. How supreme his sound is—simply continuing, improvising (a word I cannot divorce from a kind of quiet improvement) without firm rules, with neither much raucousness nor too great an attachment to harmony, moving slowly, almost silently. This is how things should be, though the implication is always that

they could be different. In fact, what sets Feldman apart is his particular cultivation of unmystical mystery, a sense that there is no pre-given order to things, but that we invent everything at any given moment.

What I find most striking about both the film and the journal is that they end on the same note: a sense of the confusion about what it is exactly that has taken place, what its potential might be and, perhaps counter intuitively, a firm commitment to *continue this confusion*. This does not resolve a debate that occurs a few times about *why* everyone is there—is it in the name of art or of something else and are we inside an Anton Vidokle artwork? I remember thinking that all this talk of "gathering in the name of" was rather biblical.[12] But then after a while, in his own time, Vidokle does explain his commitment to calling what he does art. He does this so as to keep it open, full of potential. Rather than declaring his interest, delineating what or whom he serves, Vidokle lingers in this open mode, that gets to the heart of the aesthetic as *dis*interested judgment. This condition in which you can step back to inspect a scene, partially unable to tell quite what is there, partially willfully squinting to change the appearance of things, is not so easy to find or to create. For all this talk of hanging back, maintaining the knowledge that everything is possible is hard work. This is probably why in his film, one of the first things Vidokle states is: "Anton is tired."

12 THE BIBLE IS PEPPERED WITH STORIES OF GOD TELLING HIS PEOPLE THAT WHENEVER THEY GATHER IN HIS NAME THERE IS A CHURCH. THE DEFINING FEATURE OF THE NEW YORK CONVERSATIONS—ONE THANKFULLY INSISTED UPON BY THE ARTISTS—WAS THAT WE DID NOT GATHER IN THE NAME OF ANYTHING. INVOKING THE NAME OF SAINT PAUL IN AN ESSAY ABOUT VIDOKLE MAY SOUND PREPOSTEROUS TO SOME READERS. THE IDEA IS NOT TO SANCTIFY ANYTHING THE ARTIST DOES, BUT SIMPLY TO PUT INTO PLAY CERTAIN UNUSUAL CONNECTIONS, A MOVEMENT OF THOUGHT THAT I APPRECIATE IN THE DISTINCT AESTHETICS OF PHILOSOPHERS SUCH AS GROYS AND BADIOU, PRECISELY BECAUSE THEY RENDER STORIES SCHACKLED TO INSTITUTIONALIZED RELIGIONS UNRULY AGAIN.

BORIS GROYS
AN AUTONOMOUS ARTIST

To speak about Anton Vidokle's role in the art world is not an easy task. Any attempt to conceptualize his role inevitably leads to the following question: Does Vidokle operate in the art field as an artist or rather as a social organizer, a creator, and administrator of private art institutions? I will try to explain why I think this is the wrong question. In other words, I think that today, an artist has to create an independent institutional infrastructure to remain in the great twentieth-century tradition of autonomous art. Criticizing existing art institutions is a relatively easy task of course, and one that should be fulfilled—and in recent decades it has been, in many different but equally persuasive ways. Nevertheless, institutional critique cannot change art institutions. And at the same time the practice of institutional critique puts the artist in a position that is, to be honest, less than sovereign. The artistic revolutions of the twentieth century attempted to liberate the artist from any form of servitude in relationship to any art institutions or to the market. So why do artists appeal now to these institutions—even critically— at the end of the glorious history of these revolutions? Compared to the claims of autonomy and sovereignty that were made by the protagonists of these revolutions in their early days, institutional critique seems like a regressive move. The next step, after the long period of the institutional critique, seems to be for artists to regain their sovereignty and autonomy—in short, to institutionalize themselves.

In our day, the notion of autonomous art has a bad reputation. The rhetoric of contemporary art's theoretical discourse is dominated by a critique of autonomous art in the name of critically, socially or, rather, politically engaged art. The protagonists of this discourse obviously identify autonomous art with art that wants to please the public aesthetically rather than engage it politically. But autonomous art is not synonymous with art made to satisfy the public's taste. In fact, the opposite is the case. The concept of autonomous art was developed at the beginning of the twentieth century precisely to explain why any "external" success—any recognition by audience, criticism, art

institutions, or the art market—is ultimately irrelevant for the "true" evaluation of an artwork. The goal was to liberate art from the dictatorship of public taste, from the dominance of the aesthetic judgment.

As we know, there are fundamentally only two ways for art to escape the dictatorship of the aesthetic taste: its claim to inner truth or its ethical stance. That is why art, if it wanted to be autonomous, always pretended to be true and/or good (in the moral sense of goodness). To be morally good or true is considered by any human society as something higher than simply tasteful and "superficially" attractive. That means that art, if it appeals to truth and/or a moral ideal, has a chance to dominate the pubic taste rather than be dominated by this taste. Autonomous art is art that puts truth and ethics over aesthetic pleasure. Autonomous art is a direct opposite of non-engaged art that is made for pleasure, to satisfy aesthetic taste—be it mass-cultural pop taste, elite taste, or institutional taste.

The obvious problem with an autonomous artistic attitude is that truly autonomous art does not appeal to a wide public. Truth is a minority taste. At the same time, art is not something that is made for a minority. Art is not a specialized practice comparable to botanical science or cardiology. Art, by definition, is made for everyone. Thus the modern tradition of autonomous art seems to betray art's radically democratic nature, which is why everyone involved with art is so sensitive to the accusation of being part of a closed, elite circle—and to the demand that this circle be opened to the broader public. By and large, the art community responds to this situation with political and ethical engagement on behalf of good causes. And these good causes are almost always the ones already perceived by that same broader public as being good. Indeed, social-political engagement makes sense only if it reunites the art milieu with the greater public sphere. An unusual, exotic political engagement would further dissociate an artist from the community at large. Only people like Tom Cruise, idols of mass

culture, can allow themselves an engagement with exotic, minority, even "elite" causes such as Scientology. But all this implies that the art milieu uses socio-political engagement to reconnect with the public, and in the process to substitute the submission to pre-existing aesthetic tastes with the submission to pre-existing ethical and political tastes. In fact, the progress here is not as great as it seems.

In his "Politeia," Plato asked to what a degree truth can become a political power. Or, in his terms, how philosophers can rule the political realm, instead of sophists who are engaged on behalf of various causes. His answer is instructive for the artist interested in truth. Plato says that philosophical rule is empirically improbable but logically not impossible. I would suggest that autonomous art, art that seeks truth, also resides in the gap between empirical improbability and logical possibility. It is not illogical to assume that all of mankind would be interested at some point in truth and in art that wants to reveal truth— even if, until now, that has not been the case. In this sense, there is no logical contradiction between making art for a small milieu of people interested in truth and making art for the whole of mankind. It can be shown that these two tasks are logically identical—whereas the task of making art that satisfies the aesthetic, ethical, and political tastes of a broad audience and the task of making art for all men are logically contradictory. But to supply a proof for this statement would bring us too far from the framework of this text. Here it suffices to say that there is a long history of manifestations of truth in art, among them mimetic truth, the truth of inner expression, the truth of the artwork as being a material object, the truth of the artwork as being a statement in the public space, the truth of art as manifestation and presence, and the truth of art as absence and memory.

Today we tend to see truth not as not being embodied in the artwork but as the product of a certain art practice. For us, truth is an event, a process. I would not argue for or against this understanding of truth in

general and truth in art in particular, which is deeply rooted in current philosophical reflection on the subject. It is this understanding of truth in art that Vidokle shares and which is a precondition for his artistic-organizational practice. If truth in art reveals itself not in artworks but in the processes of making art, then these processes should be rendered as transparent as possible. It is obvious that existing art institutions are not capable of fulfilling this task because their modus operandi is too impersonal and obscure. To make things more transparent, observable, controllable and documentable, Vidokle creates conditions under which he personally shapes and manages all the processes that normally take place anonymously, bureaucratically—financing, renting real estate, sending invitations, documentation and the like. Vidokle is an experimenter who places some processes that usually take place behind closed doors under transparent laboratory conditions. He has organized an art school, various art theoretical discussions, an online magazine about art and more. He did so in order to investigate all these processes on a small scale and from a short distance. By realizing and better understanding these processes and practices, Vidokle also makes them more transparent to those who may also be interested in the same questions but do not possess the means to investigate all these practices in a systematic way. His guiding passion is an artistic curiosity; he is truly interested in how things function. But Vidokle is interested in them not as a scientist—a sociologist, for example, who is interested in the things as they "objectively" happen—but as an artist who believes that one can understand something only if one created it oneself.

This strategy allows Vidokle to investigate art-related processes and practices not as they already take place in empirical, compromised "reality" (i.e., within the framework of existing art institutions), but according to a set of certain logical possibilities. In other words, he investigates these processes under artificially created conditions—as utopian artifacts. In this sense, Vidokle's projects are situated in the

tradition of social experimentation that is half political and half artistic—and that is an integral part of the history of modernism. But of course, Vidokle's projects have been realized on a much smaller scale. They are open to everyone, but they don't require everyone to participate. On the level of the logical possibility, all of mankind can participate in them. But empirically, they appeal only to an interested minority. These projects try to carry on certain utopian and experimental aspirations of early modernism without any attempt to overcome their minority status. In this sense, they correctly reflect the social and psychological conditions under which the taste for truth currently operates. Here we see an interesting case of a truly autonomous art—and at the same time a paradigmatic example of the art of our time. This art is autonomous because it creates its own institutional and economic space apart from existing institutions. And it is also autonomous because it is interested in truth and not in pleasure—even if, at least for its participants, it is pleasurable enough.

MARTHA ROSLER AND BOSKO BLAGOJEVIC
A CONVERSATION

AUGUST 6, 2009, GREENPOINT, BROOKLYN, NEW YORK

BOSKO BLAGOJEVIC We find ourselves not far from where we first met some years ago (your upstairs sitting room), under the same imposing terms of absence then as now: your impressive bookshelves, many and multiform, are empty! Will the *Martha Rosler Library* ever be Martha Rosler's library again?

MARTHA ROSLER I certainly expect my books to come back. The library has borne the imprint of a thousand fingers—including people who broke many a book's spine by photocopying pages, which is not my favorite result. But, they will be coming home, shall we say, as prodigal children—and joining the new additions bought in the interim.

BOSKO BLAGOJEVIC And yet, dispossessed of your books, your work continues: as an artist, a writer, an intellectual.

MARTHA ROSLER I'm not so sure about that, really—it's very hard to do any intellectual labor without being able to jump up and find a particular book. On the other hand, the absence of the books certainly gives me the opportunity to acquire more, or to write "on a limb," without references.

BOSKO BLAGOJEVIC Elena Filipovic has described the gesture of the Library in terms of generosity; I would agree, but I can't help but add some sense of "courage"—one's library is an intensely personal collection, often scattered among places where the public isn't typically invited to enter.

MARTHA ROSLER True, but the books have been extracted from those locations—and by no means are all of them traveling (although many people seem to believe that the Library has all my books). When Anton and I put the collection together, we decided we'd have to

make a large and fairly representative selection. It certainly wasn't exhaustive; for instance, he was not interested in including cookbooks or gardening books! If, on the other hand, the selection was too small, we risked making only a thin gesture, a physically present reading list of sorts, a prescription of what people should read versus what they shouldn't.

BOSKO BLAGOJEVIC You've done this before—invite the public into your home, although sometimes not without play. In the videotape *Semiotics of the Kitchen* you invite viewers into what looks like your kitchen.

MARTHA ROSLER It was somebody's kitchen… I shot *Semiotics* in an artist's loft, on an extended stay in New York in the mid-1970s, because it offered a setting that seemed completely artificial. *Semiotics*… was intended to be a parody of a TV cooking show, but only in a nondescript way. Of course, a cooking show's artificial set is meant to adhere to the real… I doubt I could have been living in Southern California and thinking about gender, as I was at that time, without paying attention to the domestic sphere since it is so much a central feature of feminism. But there's private and then there's private; the kitchen is not the bedroom or even the bathroom.

BOSKO BLAGOJEVIC In other projects, like *From Our House to Your House*, the annual postcard series made during the early 1970s, you feature pictures from the interior of your home or what looks to be your home.

MARTHA ROSLER Homes. There are four different places that I was living in those pictures, but one of them is a still from *Semiotics*. Again, this is about situating a social critique in the "backstage" spaces. They were my private spaces, but the form of the photo Christmas card is a mass form, which I was adapting. Typically, I used black-and-white photos despite the fact that such cards were at that point almost

uniformly done in living color. And rather than identifying myself by name, I wrote things like 5'4", 118 POUNDS, AT HOME IN KITCHEN. The card was a decoy, in other words: it appeared on its face like an intimate, personal greeting but was another sort of communication entirely.

BOSKO BLAGOJEVIC Isn't this a gesture of hospitality then? I find it a curious gesture at the heart of works that all sort of bare their critical teeth in some sense or another, works not without a political "bite," shall we say.

MARTHA ROSLER Hospitality has had some currency in the art world for the better part of this decade; maybe it is a result not just of a wide reading of Derrida, or maybe Marcel Mauss, but of the bad conscience associated with young (and even not so young) artists making pot-loads of money. But that doesn't mean that hospitality, or generosity, are completely tainted concepts. I try to open a space in virtually all my works for a viewer to step into, in fact or imagination. Including most of the photomontages. But with the Library we're talking about books; you could buy them, too. Books have a kind of commonality the way that pots and pans and towels and furnishings do not. They're not selected for their visuality, and yet together they create walls, suggestions of discourses. They're of an entirely other order of space, of personal space, than what you're talking about. I think the reason that I take that position is that the Library is always public. These are mass market books, generally. They've been published and thus part of some kind of public sphere. It is different from sending someone a photo of you standing in your kitchen. But like many feminists, I have done quite a few works that reopen a space of domesticity or friendship. *If You Lived Here…*, the project on homelessness, housing and urbanism from 1989, was obviously centered on ideas of community and stratification, and entitlement.

BOSKO BLAGOJEVIC There's a question of authorship and of proximity here, too. It's part of the draw of the piece, and you've hinted as much before: the question of whether to know the library is to know the artist.

MARTHA ROSLER That was a question I didn't even consider until the Library got its name—which was not my idea. I certainly didn't dream of naming it after myself, in a strange form of possessive individualism. It never occurred to me that people would see these books as a stand-in for me. I wanted instead to make an offering of a large number of authored works, so people could wander in the stacks and not worry so much about what was present or absent. Being in the Library has a much different character from being in somebody's house. The shelves we chose were mostly domestic bookshelves, it is true, along with some chairs for reading. There were other components though that strayed from this: a photocopy machine, for instance, which is office equipment. So there's a hybrid quality to the thing, because its components come from several places and work in various directions, and of course it is conceptually situated in the imagined community called the art world.

If I think about the garage sales I've done in and around noncommercial art galleries and museums, I always did my best to trouble the idea that all the things on sale might be the belongings of a single person. People were generally quite confused. Many held on to the idea that "she owned these things." It's similar to when we're looking at certain forms of advertising that are meant to look "realistic": it's hard to remind yourself that nothing you see in an ad can be taken as the real; we try so hard to hang on to this myth. But since I've mentioned the *Garage Sales*, in that project I intentionally united gallery-goers and the general public and suggested the presence of a homeowner no matter how institutional the actual setting, while also adding clear signs that it was an art project. I knew that most people want a bargain and don't give a damn whether it is an artwork or not.

Many people seemed to feel like insiders, in on the joke, while still walking off with desired objects. Over the years however, this form of participatory event or temporary coalescence into a community (one united by the possessive impulse) has become normalized in an art world that has left high-minded idealism far behind. It may not be all that appropriate, though, to see this as depending on generosity so much as another manifestation of the search for autonomy.

BOSKO BLAGOJEVIC The Library seems to summon a kind of engaged participant, but your own name also operates here, even if as an unintended consequence. Perhaps not in an uninteresting way. It's a bit of a decoy, the type that you've deployed many times in your work.

MARTHA ROSLER It is a decoy similar to what I was describing about *Semiotics* and the Christmas cards. But people often literalize, especially in the art world. In respect to the Library, there's a powerful effort to read the character of the owner of the books, which narrows the experience of the work. The books become jewelry or clothing, rather than, you know, *books*. If there's a portrait element at all in this project, for me it's that this is the portrait of an artist: this is what forms her world view.

BOSKO BLAGOJEVIC But isn't your name here also the key that opens the exhibition space to the Library?

MARTHA ROSLER If I had been thinking at the time I would have called it *Reading Room*, but it did not occur to me that it would *have* a name. The truth is that we never expected the project to travel. The Library was installed at e-flux's small New York space, when it was on Ludlow Street, and later at the unitednationsplaza building in Berlin. Somehow the project had become attractive to curators. Anton and I talked over a number of the requests that came to e-flux, accepting some and

turning down others, always making an effort to keep the Library from becoming "museumized." In particular, we wanted to make sure the hosts could manage the visitors, make them feel welcome and support the photocopy machine. The Library went to a couple of places before and after the two e-flux-related venues. For Paris it acquired a snazzy neon sign, in script lettering. It was in Antwerp, in Edinburgh at Stills Gallery, in Liverpool at John Moores University's art school, in Paris at the Institut national d'histoire de l'art. Anton made sure that each time there was a public discussion in which we both participated, and he managed the crucial details, such as the choosing of the shelves. Together we would make a site visit in advance before a final decision was rendered, and I also collaborated on the exhibition setup. But all the managerial and administrative moxie came from Anton; he was the roadie and project manager.

BOSKO BLAGOJEVIC It's difficult to continue without pointing to the other absence from this room, from this conversation: that of your collaborator Anton Vidokle. Our present dialogue, in fact, will be included in a book about his work, not yours. Yet he remains a ghost.

MARTHA ROSLER The project came about through Anton's suggestion, as I have been saying—he was the one who catalyzed it, who set things into action and who played a very important role in shaping it. He took an active part in deciding how and where we should present it: saying yes to this, no to that. He argued against certain venues that he felt were too museum-like, that he felt would chafe the piece. He has also explicitly pointed out the contrast with the Donald Judd Library; a library that I've never seen, but in which the books are encased in sleeves, are on the shelves and cannot be touched by visitors. Anton envisioned an artist's library that would be a resource. Although I included reading rooms and libraries in some of my previous projects, starting with *A Gourmet Experience* in 1973, I hardly imagined that I would have shipped out the vast bulk of my books and proclaimed it

an artwork. I needed Anton to push me there. And here's how the conversation went, as far as I recall. He was over for a visit and was describing his repulsion after having recently seen Donald Judd's library in Marfa, Texas, with its mummified books. I was meanwhile bitching about the fact that there were piles of books everywhere in my house, even "walking" down the steps between the floors. He paused and said, "So, Martha, why don't we borrow all your books and move them to the office?" I hesitated a beat and said, "Uh, sure! Why not?" It seemed like such an interesting idea. It was nothing like a traditional art project, yet it fit with things I had done in other shows, and in other ways.

BOSKO BLAGOJEVIC Anton here seems to be the opposite of the book collector Walter Benjamin writes about in his library essay. Rather than "freeing" commercially circulating books by taking them into a refined private collection, he frees them by making a private collection into a traveling public one.

MARTHA ROSLER Yes, his move was never intended to change the books individually or collectively so much as the channels in which they would circulate. This is why carefully considering each potential venue was so important, why this became such an issue once we left the more pliant situation of producing and exhibiting strictly on our own terms at e-flux or *unitednationsplaza*. An exhibition space can over-power a work, push it in this direction or that one, and the Library by its founding impulse demands a certain sense of autonomy.

BOSKO BLAGOJEVIC It actually seems rather immune to museumization. It appears to actually "de-museumize" space by the very nature of its logic; like a sorcerer casting a magic circle on the ground, a kind of boundary is drawn between these competing kinds of spaces for experience.

MARTHA ROSLER When we would refuse an exhibition site, the decision would often be based on the fact that the institution would allow only reduced access to the Library. Buried in a museum, the Library loses some of its public character, its accessibility to various publics. In Antwerp, in 2006, it was part of a larger show at MuHKA, but functioned relatively autonomously since the museum agreed to borrow an artist-run storefront to house the Library. Here we can see the functional effect of treating the Library as a stand-alone entity. The Library takes on a quality of unity or singularity when you approach it. It is, after all, an "installation." That unity dissolves into a diversity once you actually enter the space, but it is hard to miss its difference from most art-world installations. There were other considerations, too. We have been careful about how the shelves are arranged; I wanted to make sure that they did not just line the rooms. The inclusion of plants in most of the iterations, and knickknacks on the shelves—as in my house—was Anton's touch.

BOSKO BLAGOJEVIC Your friendship with Anton in this work undergoes a certain public enactment, being brought into the public sphere by way of the otherwise lonely act of reading—the kernel at the center of any life of the mind, but also the thing that isolates us in our studies.

MARTHA ROSLER I'm not so sure that reading a book is an isolating act, anymore than sitting in a movie theater and watching a movie with other people. Except of course when those people in the movie theater form a crowd by active viewing, responding to the screen events, for instance. But more often, we have something of a collective alienation, a passive viewing. The quiet of the movie theater is more library-like than the Library project. And as for reading, I think the degree of commonality and communality in reading is highly variable. Sitting next to someone who is also reading creates a bond of "the readers"—and I mean this quite seriously.

BOSKO BLAGOJEVIC Where does your friendship with Anton begin, then?

MARTHA ROSLER I think it was by way of *Utopia Station*, in 2003. We have many mutual friends, and they are all suspiciously tied in my mind to *Utopia Station*. My project there was so time-consuming and involved working with thirty people, and the heat was so unremitting that I can barely remember what other contributors did. But definitely Anton and I, and others associated with the wider *Utopia Station* project of Molly Nesbit, Hans Ulrich Obrist, and Rirkrit Tiravanija, used to meet for lunch or dinner and talk in New York.

BOSKO BLAGOJEVIC It's interesting thinking about this word, *utopia*, and the way your Library moves in relation to it in two ways. On the one hand, it's exhilarating to see people so engaged in an exhibition: speaking and reading! But at the same time, we're also looking at a library ensconced within a museum. Is the work a kind of eulogy?

MARTHA ROSLER It's not necessarily found in a museum, as we've agreed. As to its constituting a eulogy I've never quite thought of it that way, and I would be surprised if Anton did. But we share the sense that literacy is in question here, especially the kind of literacy related to the printed volume. As the centrality of print as the form of publishing diminishes—in some states, fiscal problems have brought about the recent cancellation of textbook purchases in favor of online texts and college-style compilations (think Kinko's)—there have been many more so-called artist's books and catalogues produced than ever before. Aside from our long-standing love affair with obsolete technology, this growth spurt is due in part to the availability of fairly inexpensive printing, even of volumes in small numbers, but also it evidences a desire in the art world to get things validated by the printed source. Catalogues constitute a publicity machine for artists and dealers: to have the catalogue, the book, after a show.

BOSKO BLAGOJEVIC It was curious to me, while I was working for you, how often art history students would visit your studio and spend hours searching through your remaining books looking for this catalogue or that one. As if the catalogue has become a kind of platform from which art histories are written.

MARTHA ROSLER But that is so lazy! An entire generation of art historians will grow up thinking that shows are the primary way to understand an artist and that catalogues are central to this understanding. Catalogues are nothing—a predigested take, a snapshot, maybe, of what the artist or someone else had to say about a body of work at a certain time. It's the same kind of laziness that has engendered a situation in New York today in which critics or curators have come to rely on the commercial gallery system to make artists visible. One young art historian presenting a paper about my work was crushed by the fact that it had not been included in an early East Coast feminist show. She took from this that I somehow must not have been a visible feminist artist in that period, which is easily contradicted. But still she was hardly quieted to learn that I was living and working—and in grad school—in California and therefore not likely to have come to the attention of the show's organizer.

In recent decades "postmodernism" and its sequels, despite artists' big push for autonomy in the 1960s and 1970s, have undergone codification at the hands of an increasingly prepotent set of controlling institutions, from art and art history departments to magazines to museums and commercial galleries. Let's remember the right success-fully removed the gift economy form the institutional frameworks of art—no more grants to artists, no grants to adventurous art institutions, if possible no more artist-run spaces. Instead everything is routed through the money economy. I think fewer and fewer young artists learn that the art world movements of the 1960s consisted in large part of artists seeking to retain autonomy from these very same confining

and credentialing institutions, and if possible from the reduction of the work of art to a fungible commodity. One evaded the commercial system and instead worked in college and university teaching until, beginning round 1980, the entire floating ice sheet of alternative, generally artist-run, generally taxpayer-funded spaces dissolved into ice floes and then into running water, and we cannot walk on water. I agreed to join a gallery when it became absolutely clear that the shift I mentioned had been completed, and curators and critics were largely seeking the new big thing in commercial gallery rosters. I was widely known to contemporary art historians and certainly to other artists, but no collector had ever heard my name: two different worlds.

BOSKO BLAGOJEVIC When the word "autonomy" is bandied about now, it's often used to describe an artist's aesthetic autonomy within the exhibition space or from art history, rather than an autonomy to act in the world beyond those spaces.

MARTHA ROSLER The noose has tightened so dramatically that people don't know how to think in other ways, to have other ambitions. Instead, it sometimes seems that every effort to escape the charmed circle of the art world is a feint designed to get inside. In the '70s and '80s, clever academics reminded us that there is no "outside"; like other postmodern nostrums, this idea was deployed to advantage in the U.S. by artists who were interested in making money and simply not caring a bit about autonomy from the concentric rings of institutions. What is terrific about Anton is that he feels absolutely no need to follow this model or accommodate the sclerotizing habits I have been describing, and he doesn't even pretend to follow the models of pro-fessionalization offered as the only choices. He is an autonomous player in that regard. He is independent of reviews, notices and galleries. He simply does what he wants. To some degree this is possible because he has subsidized his projects through the success of his first autonomous entry into the art world ambit, the e-flux

announcement list, which perhaps paradoxically depends on the institutions of the art world to prosper. e-flux also gives him credibility as an authority. Everyone has to make a living, let's not be mistaken. The traditional way, for postwar artists like myself, has been to teach, as I mentioned earlier. But there are fewer and fewer teaching jobs, so that there has to be another rationale for attending grad school, which has been termed the success model—defined, essentially, as gallery representation.

The thing about e-flux is that it is an alternate system that haunts the institutionalized gallery/museum system. e-flux's presence is widely known, praised, and felt, but definitely e-flux is not in thrall to institutions. e-flux is run by a collective, so he is not the only person directing e-flux and its associated initiatives—let's not forget Julieta Aranda—but his is the steadiest hand. Julieta has chosen a different practice in her art from most of Anton's works and seems to accept the standard institutional frame more often—as do I, let it be said. But Julieta is still in the e-flux camp and helped organize many of their important initiatives, such as the traveling video library, and is currently working on a new project with Anton, a barter system.

BOSKO BLAGOJEVIC Would it be unfair to characterize e-flux's recent work as driving these slightly elegiac vehicles to create meaning and clear spaces for agency? A video rental store, a pawnshop, a free school, an arts journal: they are organizational forms that seem to be spiraling towards obsolescence or radical transformation.

MARTHA ROSLER Anton's a kindred spirit to me in that sense. I often use forms that are somewhat quaint and soon-to-be outmoded so as to turn the lens slightly, as it were, on our perceptions of the world. (Even *Semiotics of the Kitchen* relied on hand tools, not the electrified kitchen armamentarium of the day.) I think that's why the Library project was something we could agree upon very quickly.

Art is always attracted to forms that are passing away, attracted to the halo of obsolescence. Artists adopt or toy with these forms at the moment in which the mass public ceases to be interested. The thing in question reminds us of everything we might have been yesterday but have since denounced: our parents, the social stratum in which we are born and somehow hope—in whatever way—to transcend, and so on. It is also a kind of encounter with our own death, cultural or otherwise. This is an interesting state in that it allows us to examine the recent past while remaining alienated from it, the very thing that now constitutes the fabric of our present. There is talk in some academic libraries of discarding entire stacks in order to better facilitate technical upgrades, and this is already happening at various technology-oriented universities across the country. The fervor of the technocrats at the helm of these projects betrays exactly the type of alienation of which I'm speaking.

BOSKO BLAGOJEVIC When I think about artists and libraries, Paul Chan's online Library of Alexandria is one of the more interesting to come to mind, especially in relation to yours.

MARTHA ROSLER Paul's project underlines the text as both disembodied and collectively shared but also as "owned" by a particular reader. Paul also collaborated in the study group sessions that accompanied the Library project when it was in New York. His library and my own are of different scales and different modes of performativity: a few dozen manuscripts read aloud and presented as audio versus a dozen or so material shelves: texts versus book-objects. The means of access are also central to the question: the voice in opposition to the printed word. While we persevere in remembering our foundational national mythos as a society of written laws, nothing could have made more obvious our vulnerability to autocracy as the fate of laws during the Bush administration—the letter's subjection to primacy of the autocratic voice. And not simply the liberties codified into the Bill of Rights but even

the most unequivocally established elements of English common law such as habeas corpus: the right to be confronted with evidence and one's accuser in a court of law. Turning back to the libraries, however, Paul's work is still—and he's said as much many times—very much about a certain dispersal of power, a disenchantment of its grip on the everyday. His library, likewise, is not an inhabitable place, but is itself dispersed. It is somewhere where we might come to listen, but never meet, as bodies, together. The texts are "there," but likewise disembodied. Anton and I work in a different direction, and our republic of letters is in this instance constituted as a physical place to which one might repair. In at least one of the venues, people chose readings from the Library and paired them with other readings not physically present: texts always demand to be voiced, and to be accompanied by other texts.

BOSKO BLAGOJEVIC In a conversation held last summer in e-flux's New York space, as part of *The New York Conversations*, you spoke about utopian horizons for work; about always looking and working toward an imagined future, a desirable future.

MARTHA ROSLER There is a very traditional humanist, Enlightenment striving here: thinking is free and thinking will make you free. Or, in other words, more information is better than less, and becoming involved in researching something simply for pleasure, or reading or studying a book—a great work or a bit of ephemera—marked by somebody's authorial intelligence has the possibility to deepen your vision. It's a horizon of communality, against which the work exists, in which information is shared in a particular form: print. The Library is a project very much about the *idea* of depth—knowledge in depth, or immersion in depth, in which you're drawing upon, or gaining from, people who are not physically present. It remains a site for self-teaching and self-guiding, in, of course, a conditioning environment.

BOSKO BLAGOJEVIC Related to all this is an ongoing and not insignificant debate in library science itself—that is, what is, or was, the Library: a thing or a place?

MARTHA ROSLER I don't know about *thing*; it certainly is a place, as I've suggested. It's a portable place, much like a traveling tent show. I would strongly argue that library buildings are crucial sites and that it makes a great difference what a library building looks like and how the contents are organized. Here in my Greenpoint, Brooklyn neighborhood—right around the corner, in fact—there is a fine example. The first public library was built by Andrew Carnegie, the industrialist who sought to placate the gods of history by devoting much of his ill-gotten fortune to the edification and uplift of the masses; eventually he even earned himself the sobriquet "Patron Saint of Libraries." The model, built at the turn of the twentieth century, was a Beaux Arts building, well appointed and with a suitably impressive facade, with local "branches" sited all over the city. During the great wrecking called urban renewal of the 1960s and 1970s, our local example was torn down in favor of a vile, stripped-down, one-room brick bunker surrounded by a high iron fence. Don't get me started on the contents! The magazine reading area was completely ditched for an array of computers, used by kids to surf entertainment and porn websites. They also replaced a section of books with Brooklyn Public Library's Bulgarian collection. It was a curious decision, since Greenpoint is a Polish-immigrant neighborhood with an increasing South Asian (and now hipster) population. When I raised the point to one of the librarians about the Polishness of the neighborhood, she replied, "Yes, that's true, but Greenpoint is midway between the Bulgarians in Brooklyn and the Bulgarians in Queens." The public libraries, like the domain of letters everywhere, are trying to determine their new role and how to serve their client populations in light of globalization and the acceleration of information technology development. The model of indoctrination into the ethos of the West through literacy is a project of the industrial era;

in post-Fordist times, other modes of address and other routes to the disciplines of literacy in diverse modes and even in languages formerly discouraged are now under construction. Just get 'em into the system, even if they are after foreign diversions, DVDs, or internet delights. Here The Building itself stands as a collector and shaper of citizens.

A living library isn't a closed entity—its contents remain mutable. It's not unlike a human body, constantly mutating while also retaining an identity: "me," "I," the discrete subject. But this may not be what the librarians you mention were arguing about …

BOSKO BLAGOJEVIC Whether we can think of the library as a way of organizing resources or whether we can think about it in terms of a structure, a place for bodies to come together. Not necessarily a building.

MARTHA ROSLER Well, you're desscribing a building. It requires a certain form in the built environment, a shielding from dispersal by disquieting means. A library sets me to dreaming; perhaps it does so for everyone. Each title evokes a possibility; each book is a kind of separate world. When I was a schoolchild in Brooklyn, the weekly visit to the Library was at the heart of my self-chosen experiences and helped me create my world. Later, when I worked in the magazine section of my high school library, my job organizing the old magazines, with their ads for armaments and home appliances, helped found my subsequent body of photomontages. When we were setting the Library up for the first time on the Lower East Side, a backpack-bearing boy of about 8 or 9, walking along with his brother and father, ran up to e-flux's store-front window. He called, "Look daddy, a bookstore!" He was genuinely excited by his find. It was a poignant moment, since there are no bookstores around there. There may be libraries, but not bookstores. He was obviously thinking about books in terms of buying them, and it made me wonder whether he was familiar with libraries. I went outside and explained to him that it wasn't a bookstore, and that it wasn't open

yet, but that he could come back anytime, that we had lots of children's books and so on. I'm not sure if he did or not, but if he has retained any of that delight—he became a reader on the spot.

On the downside, however, this episode also set me to thinking about what a bookstore might mean to him: a place to buy books in order to get to them, a sign of the shrinkage of the notion of the public, the commonality of books as a shared cultural "space." Led by Barnes & Noble and Borders, but following many an independent bookstore, readers have been encouraged to sit down and to dip into the books for sale, buy some pricy coffee and so on: acts along a stream of expenditures for small luxuries, intended to accompany laptop use, and engender or complement social activities such as eating and drinking and talking—the kind generally discouraged in public libraries.

A good comparison was the response of a South African friend whom I had met in Capetown and who worked with me extensively on a video project there and the nearby townships. He visited my house in New York and when he entered the library, or book room, which is a separate room lined with shelves up to the 14-foot ceiling, there was a sharp intake of breath. "Why do you have so many books—you own them?!" He was scolding me; "In South Africa, we have libraries, we don't hoard books and keep them to ourselves!"

This was in the back of my mind when Anton proposed the book project: that the same room, so to speak (and the contents of books from many other rooms, ultimately) *could* be transformed into a much more public place, a shared space.

BOSKO BLAGOJEVIC Well it would certainly seem to me that your Library has become a place: a stage engaged by a changing set of unsolicited actors. Readings, discussion groups, conversations, for instance, seem to take seed here. Talking in this library certainly isn't prohibited.

MARTHA ROSLER When we would install the library, we would set up initial reading groups. In some venues, meanwhile, people approached us about using the Library as a platform for their own projects, to stage readings, as I mentioned earlier… to bring things, to organize events, to screen films and so on, and of course occasionally to donate books, a nice gesture. In each venue people had different ideas, but this is not so new. Projects of mine which contained smaller libraries had seen this kind of activity, too. During the *If You Lived Here…* cycle at Dia in 1989, or earlier, with *Fascination with the [Game of the] Exploding [Historical] Hollow Leg* in Boulder, Colorado, in 1983, I also held forums, group performances and discussions as part of the exhibition, which sometimes took place in the exhibition space and sometimes in meeting rooms nearby. I think that anything that puts a person in mind of wanting to collaborate, or wanting to "speak next to" something, was considered.

BOSKO BLAGOJEVIC It moves the question of "thing versus place" to whether culture is a thing or a place, and it seems very much that in your work and in Anton's work it has consistently been a place; and a place of much activity and much communality. But is it also a deliberate return to the local, or a series of returns to various localities?

MARTHA ROSLER Ah, but I used to do mail art; specifically, serial postcard novels. Anton's projects meanwhile always have that quality to me: of people sitting around together and having a conversation, making choices from a finite offering organized by him or other artists whom he has invited… much like old-fashioned coffeehouses and cafés, where one sat for hours and argued philosophy, literature, or or film with one's friends, or plotted revolution—not the Starbucks model, in other words. It's funny, because e-flux—the fee-for-service announcement list—is precisely the opposite: international, ubiquitous, invisible, dispersed across time and space. e-flux is like yelling down a well, but one from which everyone can draw. Information transmittal is totally

noncorporeal, but Anton's other projects tend to be on relatively small scales. The journal still exists only in digital form, but I wouldn't be surprised if it takes on the garb of print and becomes embodied. The Library may have seven or eight thousand books in it, but that's a fairly small library! *e-flux video rental* probably has some several hundred tapes, but still, many fewer than commercial video rental stores of the recent past. The miniature element, or just smallness of scale, is critical in establishing a community of visitors and participants, in something like a comfortable (if not intimate) space that is in great contrast to the metastasizing art galleries and ever-larger museum galleries in which work is usually exhibited, seminars held and so on. The backdrop of institutional aspirations is thankfully absent.

BOSKO BLAGOJEVIC But if art has been functioning as a social space—a managed or provisional space—for you and some of your colleagues, what are the implications for other areas of public life?

MARTHA ROSLER I think we agree that the face-to-face public sphere, à la the old coffeehouse model, is under severe stress. Although people have access to the internet at work, its use for projects other than what one's job calls for is generally expressly forbidden, and access is often monitored, keystroke by keystroke (a technology in use by employers since the late 1980s). The newer modes of connection, including Facebook and Twitter, are more a sign of the commercialized banalization of life than of the transmission of a robust discourse affecting matters of public life. (But one must note the recent use of Twitter, which is still in formation as a commodified service provider, during political crises in India and Iran.) Thanks to the technologies of interconnectivity, the lines between leisure and work, bought time and free time, continue to blur, which is accelerating the collapse of the putative public/private split, leaving the public sphere—the space of citizenship—as the increasingly unrecognized, unrecognizable social space.

But looking at this from a different angle, I believe that people naturally push against the scale of something—whether they push the walls outward when the space is too small or draw a circle inside an interior space that has become too big. I think in light of the scale of exhibitions in contemporary art, the search now is essentially for a comfort zone for the people who inhabit these worlds, both physical and mental comfort, where personality and a sense of choice may be retained rather than made subservient to the choices of others. The art world has gained a kind of impersonality brought about by scale, the commercial gallery aping a vast museum but largely as a monoculture, devoted to a single show, so I think that people are often relieved to come into smaller worlds, smaller rooms. This is again also about artistic autonomy, about creating systems that look like other systems, but remain artist-made systems—which means they're made to satisfy an artist's intended scale, an artist who may be interested in communality and questions of "the public" as opposed to, say, monumental sculpture or grand gestures.

BIOGRAPHY

Anton Vidokle was born in Moscow and is currently based in New York and Berlin. His work has been exhibited in shows such as the Venice Biennale, Lyon Biennial, Dakar Biennale, and at Tate Modern, London; Musée d'Art moderne de la Ville de Paris; Museo Carrillo Gil, Mexico City; Haus der Kunst, Munich; P.S.1, New York. With Julieta Aranda, he organized *e-flux video rental*, which traveled to numerous institutions. As founding director of e-flux, he has produced projects such as *The Next Documenta Should Be Curated By An Artist*, *Do it*, *The Utopia Station poster project*, and organized *An Image Bank for Everyday Revolutionary Life* and *Martha Rosler Library*. Vidokle initiated research into education as a site for artistic practice as co-curator for Manifesta 6, which was canceled. In response to the cancellation, Vidokle set up an independent project in Berlin called *unitednations-plaza*—a twelve-month project involving more than a hundred artists, writers, philosophers, and diverse audiences.